CHARLOTTE
 BEER

CHARLOTTE BEER

BEER

A HISTORY OF BREWING IN THE QUEEN CITY

DANIEL ANTHONY HARTIS

PHOTOGRAPHY BY ERIC GADDY ‡ FOREWORD BY WIN BASSETT

AMERICAN PALATE

Published by American Palate
A Division of The History Press
Charleston, SC 29403
www.historypress.net

Copyright © 2013 by Daniel Anthony Hartis
All rights reserved

First published 2013

Manufactured in the United States

ISBN 978.1.60949.846.7

Library of Congress CIP data applied for.

Contents

Foreword

L ong before I became executive director of the North Carolina Brewers Guild (using the craft beer scale measurement of "long," which means anywhere from a few weeks to just shy of a year), I knew the author as @CLTCraftBeer and later as @charlottebeer on the social media site Twitter. In a time where people make in-person introductions using Twitter handles, especially in the small, yet boisterous online beer community, @winbassett had no clue who Daniel Hartis was. Introduce the latter at a party as @charlottebeer, however, and we had been best buds for a "long" time.

Despite communicating with him on an almost daily basis for about a year, I didn't meet Daniel in real life until the evening of Friday, August 24, 2012. I was in Charlotte that weekend for the grand opening of North Carolina's sixty-ninth brewery, Triple C Brewing, and though I had visited the Queen City several times in my tenure of leading the guild, my path and Daniel's had yet to cross. The night before the brewery's opening, however, the stars aligned at a mutual friend's bottle party—a friend, I might add, whose acquaintance I also originally made online.

Daniel wasted no time introducing himself as soon as he walked in the door of our friend's gorgeous house, and I could immediately tell that the passion for craft beer and, more specifically, Charlotte beer embedded in real-life Daniel Hartis exceeded or surpassed the @charlottebeer I knew from Twitter. It came as no surprise to me, then, that The History Press recruited him a few months later to literally write the book on his city's brewing history.

A few years ago, had someone told me he or she was writing a book about Charlotte's beer community, I would have told him or her to consider creating a long-form magazine article, a succinct website or a short e-book equivalent to today's Amazon Kindle Single. Little did I know that new breweries and brewpubs, a handful of bottle shops, beer running clubs, female beer meet-ups, monthly beer dinners and a slew of beer festivals would soon begin to bring the Queen City's beer scene to life, a scene that had been left in the dust by other parts of the state, such as Raleigh/Durham, Greensboro/Winston-Salem, and the reigning Beer City, USA winner—Asheville.

But, as you'll discover in the following pages, these areas of North Carolina aren't the only players in town any longer. Charlotte's craft beer community awakening, along with its often unknown historical foundations, have been well documented by Hartis. From Captain James Jack's famous tavern to Dilworth Brewing's Brew Pub Poets Society, and from the Olde Mecklenburg Brewery's John Marrino spending time in Germany at a water treatment plant to NoDa Brewing's Todd Ford piloting planes across the world, *Charlotte Beer: A History of Brewing in the Queen City* covers the gamut of how the city's beer culture evolved and what makes it special today.

Hartis illustrates this when he describes how the owners of Triple C Brewing delivered its first keg to a nearby restaurant and bar via Charlotte's light rail system before the brewery opened on that aforementioned fateful weekend that we shook hands. "The keg was empty as it is illegal to transport alcohol on the light rail, but it was a symbolic gesture that signified the brewery's commitment to South End," he writes.

Fortunately, for Charlotte beer lovers and beyond, Hartis's hard work and fervent dedication in documenting the city's beer beginnings and contemporary developments illustrate a similar gesture of his commitment to Charlotte's beer community. He notes that Heist Brewery founder Kurt Hogan said, "We just really want to show Charlotte something they've never seen before." Hartis has done just that with what I'm sure will be known as the definite treatise on Charlotte beer.

<div align="right">

Win Bassett
Executive Director of North Carolina Brewers Guild
Interim Secretary of North American Guild of Beer Writers

</div>

Acknowledgements

I first have to thank The History Press for approaching me about writing this book, for which I am forever grateful. During the months that followed, I was fortunate to have help from many amazing people in my quest to document Charlotte's brewing history.

For pointing me in the direction of so many old city directories and vertical files, I have to thank Shelia Bumgarner and the other librarians that work in the Robinson-Spangler Carolina Room of the Charlotte-Mecklenburg Library. So much of the content they shared with me is not digitized, and this book would have been less extensive if this information was not included.

As helpful as those old archives were, I owe a sincere thanks to every person who took the time to share with me—in person, by phone or by e-mail—the memories and experiences they had during Charlotte's craft beer movement in the '90s. You will find most of these people quoted in the book; I only regret that I did not get a chance to speak with as many people as I would have liked, but then I think that could always be said of a project like this.

Thanks to local historian Jim Williams for pointing me in the right direction regarding early taverns in Charlotte. Many thanks to Bobby Bush for the numerous articles he wrote about Charlotte breweries in the '90s and for fielding many questions along the way. Relatively little was written about the breweries in newspapers, but Bobby's collection of articles really provided me with a greater picture of these breweries.

Speaking of pictures, I owe a huge thanks to my friend Eric Gaddy for most of the photos you will find in this book. I have long been a fan of Eric's work, and it was fun to work with a friend and fellow beer lover. I think you'll

find his photos to be a great accompaniment to the text. I would also like to thank Tom Henderson for graciously allowing me to include some of the photos he has taken over the years, just as I would like to thank anyone else who supplied older photos (which are credited throughout the book).

I appreciate all of the people behind Charlotte's current breweries for inviting Eric and I in to take photos or listen to their stories. It was a pleasure to hear the journey every one of you undertook, for which we Charlotte beer drinkers are all grateful.

Thanks to Win Bassett for being one of the first to read this book and for writing the foreword that you just read. As executive director at North Carolina Brewers Guild, Win has done as much for this state's beer scene as anyone. It was an honor to have him involved in the project.

I sincerely think Charlotte is home to one of the country's best craft beer communities. Without you, dear reader, I don't think I would have ever written about beer at www.charlottebeer.com, much less authored a book on the subject. Through your passion for local beer, you have demanded this book in so much as you have demanded the many bars, breweries and bottle shops that call Charlotte home. Whether we have shared beers in person or simply talked about beer online, I appreciate every single one of you.

Thanks to a family who very early on inspired in me a love of literature and storytelling. Most of my family members are not beer drinkers, and yet they listened in earnest as I spoke about the project and encouraged me, as they always have.

I am grateful for all of these people, but I can say with certainty that this book could not have been written without my beautiful wife, Airen. Many were the nights in which I was out "working," interviewing folks for the book, while she was at home with our two children. Though I am hesitant to call that work and enjoyed every bit of it, there were also many nights that I wished I was at home with the three of them. As I wrap up this book, I look forward to doing just that.

Introduction

When The History Press approached me about writing a book about the history of Charlotte beer, I must admit that I was skeptical. Don't get me wrong: we all know Charlotte's beer scene is booming at present, but what about its past? Outside of our current scene, was there enough of a brewing history to merit an entire book on the subject?

I had to craft a proposal for The History Press saying just that, so I immediately began digging into old magazine and newspaper articles, city directories and obscure niche publications (*Industrial Refrigeration*, anyone?) to find everything I could on past breweries in Charlotte. I uncovered a tavern owner turned patriot whose name would later be lent to a beer from the Olde Mecklenburg Brewery.

I found references to beers that—because they were brewed with ingredients like persimmons, spruce or molasses instead of barley and hops—were not really beers at all. I found that ancient trading paths brought many a weary traveler to Charlotte for a beer long before those paths were called Trade and Tryon Streets. I discovered bakeries that brewed beer (or breweries that baked) and breweries that won medals at the Great American Beer Festival long before the Olde Mecklenburg Brewery and NoDa Brewing Company would do the same.

I didn't start drinking craft beer in earnest until around 2007, long after those breweries (save for Hops and Rock Bottom) had closed their doors. Writing about these breweries made me regret that I never had the chance to visit them. I'll never get to enjoy an award-winning Albemarle Ale at Dilworth Brewery while listening to members of the Brew Pub Poets Society,

nor will I ever grab a muffin and a beer at the Mill Bakery, Eatery and Brewery. I'll never sip on a Bombay Pale Ale at Southend Brewery and Smokehouse, just feet away from Carolina Panthers players spilling in after a home game.

What I do have—and what I'm all the more thankful for after writing this book—is a city that is home to a diverse selection of microbreweries, many of which have undergone expansion and thrived even in their infancy. What my research has shown me, though, is that no brewery is destined to go the distance. Some of the '90s breweries that I write about in this book—namely Johnson Beer Company and Southend Brewery and Smokehouse—were once among the largest in the region. The Robert Portner Brewing Company's Charlotte depot was one of that company's last to close, as was the Atlantic Company's brewery that called the Queen City home from 1936 to 1956.

The craft beer industry is much larger than it was in the '90s, and I think drinkers today are more dedicated than ever to their local breweries. Still, do not waver in your support for Charlotte's breweries, as larger breweries than our current ones have failed. We are living in a golden age of craft beer—both in Charlotte and the nation on the whole. By supporting our local breweries, we can ensure that this golden age lasts for many years to come.

Of course, there is much more to Charlotte's beer culture than its breweries. Because this book focuses on the latter, it neglects to mention the many bars, restaurants and bottle shops that have added just as much to our beer scene. Many of these businesses embraced craft beer long before most of the breweries came to town and likely paved the way for these breweries by showing them that Charlotteans had a thirst for well-made craft beers.

Charlotte is also home to several beer groups that are certainly worth your attention. As founder of the Charlotte Beer Club, Darrin Pikarsky has worked tirelessly as a promoter of beer events, including the very popular Charlotte Craft Beer Week. You have likely seen the Charlotte Beer Girls at many a festival, where they raise money for a variety of charities. Don't confuse them with the Charlotte Beer Babes, though, as the latter group organizes tastings and beer education events for women in Charlotte.

After all of my research, I stepped away from the dusty newspaper clippings and city directories confident that Charlotte has a history of brewing and that it is worth telling. It is very much a living history, as shown by new breweries like Free Range Brewing and the Unknown Brewing Company, both of which hope to open in 2013. My only hope is that you enjoy reading this history as much as I enjoyed writing it.

Cheers!

CHAPTER 1
Charlotte's Most Famous Tavern Keeper

At what fountains had they been drinking such inspirations, that here in the wilderness, common people, in their thoughts of freedom and equality, far outstripped the most ardent leaders in the Continental Congress?
—William Henry Foote, Sketches of North Carolina, *1846*

The news reached Charlottetowne on May 19, 1775: the British had massacred colonists at the Battle of Concord and Lexington. It was enough to push many men in Charlottetowne to action. Already contemptuous of King George III's unjust laws, a group of Patriots worked through the night to draft documents that to this day are the subject of much debate. Some say these men drafted the Mecklenburg Declaration of Independence, which, if true, would mean this declaration predated the United States Declaration of Independence by more than a year. Others say these were merely resolves similar to other resolutions that had been adopted in the colonies and that, while they were radical, they were not outright declarations of independence.

Whether these papers were a true declaration or a set of resolves, they were treasonous. Anyone harboring such documents would undoubtedly be hung if caught by the British.

That didn't stop one man from embarking on the long journey to deliver the papers to the Continental Congress in Philadelphia. Often referred to as "the Paul Revere of the South," Captain James Jack is without a doubt Charlotte's most famous tavern keeper. Modern-day Mecklenburgers can still find Captain Jack's name around Charlotte. Captain Jack is there at the simple, concrete

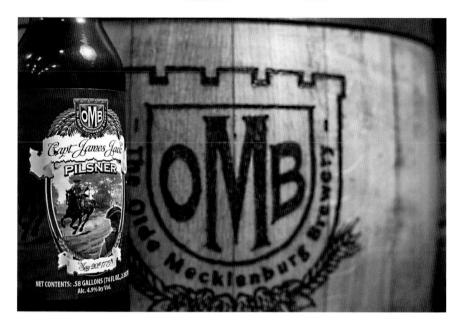

The Olde Mecklenburg Brewery's Captain James Jack Pilsner takes its name from Captain James Jack, the Charlotte tavern owner who delivered the Mecklenburg Resolves (and some say the Mecklenburg Declaration of Independence) to the Continental Congress in Philadelphia. *Photo by Eric Gaddy.*

marker noting the location at which his tavern once sat. He is there at the new statue *The Spirit of Mecklenburg* at the Little Sugar Creek Greenway and the even newer *Matheson Bridge Mural*, which illustrates the Mecklenburg Resolves in brilliant colors. And, of course, Captain Jack is there gracing the label of the pilsner from the Olde Mecklenburg Brewery that shares his name.

How would this pilsner have compared with beer served at Captain Jack's tavern? The British burned Captain Jack's home, which also housed the tavern, in 1780 when Cornwallis marched through Charlotte. Many think that, if there was a Mecklenburg Declaration of Independence, it was destroyed in this fire. If the existence of these historical documents is still up for debate, then it should come as no surprise that a tap list for Captain Jack's tavern is nowhere to be found.

So what did people drink in taverns like Captain Jack's? In *Hornets' Nest: The Story of Charlotte and Mecklenburg County*, LeGette Blythe and Charles Brockman write that "nearly everybody drank hard liquor in early Mecklenburg. Corn whiskey was the standing drink, for both winter and summer."

That doesn't mean, however, that beer was not brewed in what was then called Charlottetowne. The reason there seems to be a dearth of beer-related

A History of Brewing in the Queen City

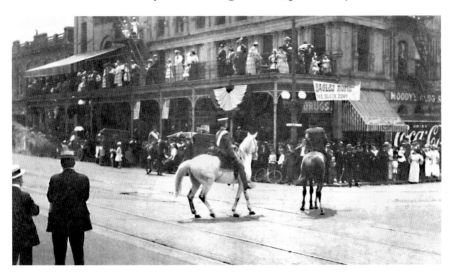

Presbyterian Hospital's first location was on the second floor of this building, located at the corner of Church and Trade Streets. The first floor of the building was home to Last Chance Saloon. In this turn-of-the-century photo, people gathered for a parade celebrating the Mecklenburg Declaration of Independence. *Courtesy of the Robinson-Spangler Carolina Room of the Charlotte Mecklenburg Library.*

records for colonial Charlotte is likely because beer was so commonplace that it needed not be mentioned. In early America, where potable drinking water was sometimes scarce, beer was often one of the safest beverages at hand, as the brewing process killed off harmful bacteria. Most early settlers brewed at home (this was often done by the lady of the house), though the resulting concoction bore little resemblance to modern-day beer.

Today, we usually classify beer as a fermented beverage brewed with malt, hops, water and yeast. Because traditional brewing ingredients such as barley and hops were often tough to come by, early colonists in North Carolina used an array of additions to produce "beers," including ingredients such as persimmons, cedar berries, stalks of Indian corn, molasses, spruce, ginger, locusts, pineapples and even pea shells (though not all together!).

In *North Carolina and Old Salem Cookery*, Beth Tartan lists a quick recipe for persimmon beer: "A peck of full ripe persimmons is enough for a 10-gallon cask. Mix up a little bran with persimmons. Add warm water and mash well. Put in a tub or barrel with straw in the bottom and let stand in a warm place." Much later, in 1826, the Mecklenburg Agricultural Society would often take out ads in the *Catawba Journal* offering five dollars for the best ten gallons of malt beer.

CHARLOTTE'S TAVERNS AND SALOONS

Outside of the home and the beers brewed therein, Charlotte held many taverns that stocked beers like the ones mentioned above. Tavern rates that were regularly published by the county court give an indication as to what beers you might find in one of Charlotte's taverns. A rate card from April 20, 1775—exactly one month before the drafting of the Mecklenburg Resolves—lists imported strong beer as well as "strong beer of this province produced," which seems a more eloquent way of saying "local beer." Another rate card from 1804 distinguishes between "London Porter" and "Strong Beer (home made)," with "home made" seemingly referring to the beer being made in the state or locally but not at the tavern.

At most taverns, these beers shared the menu with whiskey, brandy, rum, wine, punch, cider and various toddies. Daniel B. Thorp wrote of the taverns in colonial Rowan County, Mecklenburg's northern neighbor. In his research, he found that "Throughout Rowan County, distilled spirits—whiskey, rum and brandy—were served more often than beer, but the ratio of spirits to beer varied from place to place." Scottish settlers preferred spirits, whereas those of German or English lineage favored beer. Because Charlotte was home to more of the former than the latter, it is possible that spirits were more popular than beer in Charlottetowne's taverns. Thorp also came across a Rowan County tavern's order for metheglin, a spiced mead. Unfortunately, detailed records of Charlotte taverns at the time are few and far between. We don't know exactly what beers were served in Charlotte taverns or what activities took place therein, but there's no reason to think they would differ drastically from those elsewhere in the state.

No matter the type of beverage imbibed, a tavern was much more than a spot in which to grab a drink. Though the Mecklenburg Declaration of Independence was conceived and drafted in Charlottetowne's courthouse, it could just as easily have been dreamt up in a local tavern. Between sips, taverns were filled with discussions of matters great and small. They were a constant solace to locals and a welcome respite to road-weary travelers.

Such travelers frequently passed through Charlotte, and the trade routes that ran through it made the town an ideal setting for taverns. As Trade Street's name might imply, many entered Charlotte on that road in hopes of selling or trading at the intersection of Trade and Tryon, known as "the square." Named after North Carolina's seventh governor, William Tryon, Tryon Street was the name given to the portion of the Great Wagon Road passing through Charlotte. The Great Wagon Road stretched from

An ad for Joseph Fischesser's Imperial Saloon in the 1879–80 *Charlotte City Directory* advertises "beer, ale and porter." In 1880, Charlotte was home to seventeen saloons. *Courtesy of the Robinson-Spangler Carolina Room of the Charlotte Mecklenburg Library.*

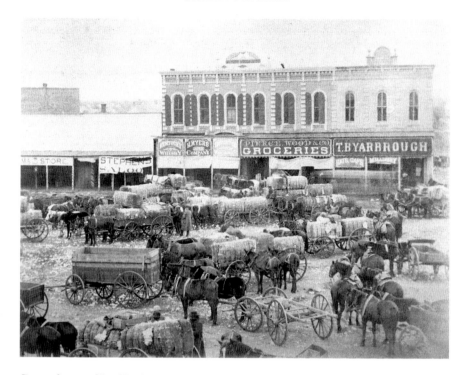

Cotton farmers fill a Charlotte street at the turn of the twentieth century. Stephens Saloon can be seen behind them. *Courtesy of the Robinson-Spangler Carolina Room of the Charlotte Mecklenburg Library.*

Philadelphia all the way to Georgia, and many of Charlotte's early Scots-Irish population came to the town from this road. This was also the path on which Captain Jack rode to Philadelphia while allegedly carrying the Mecklenburg Declaration of Independence in his boot.

Though Captain Jack's tavern is likely Charlotte's most famous, annual tavern licenses—which were issued by the court—show there were several other taverns in Charlotte during the 1770s. There were three licensed taverns in 1774, six in 1775, six in 1778 and ten in 1779. In the years to come, many more people would come to Charlotte by way of Trade and Tryon, and with them came more taverns and a greater variety of beers. Because tavern owners may not have gone to court to obtain or renew their licenses, there may have been more than is shown in the few license records that still exist.

While many of these licenses or bonds still exist for taverns in neighboring counties, I could find but one Mecklenburg County tavern license binding John McClure to maintain a tavern containing "good wholesome, and

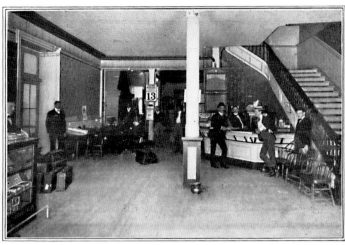

Charlotte's Central Hotel was one of the most popular places to have a beer in its day, as all of the railway's cars stopped there. *Courtesy of the Robinson-Spangler Carolina Room of the Charlotte Mecklenburg Library.*

cleanly lodging and diet for travelers, and stabling, fodder, hay, corn, oats, or pasturage, as the season shall require, for their horses." If McClure did not provide such, or if he permitted "unlawful gaming" or allowed any person to drink more than necessary on the Sabbath day, the bond would have been rendered void.

By 1800, Charlotte was home to a number of taverns that served a population of only 276 people. Popular taverns halfway through the nineteenth century included the Charlotte Hotel, Mansion House and Carolina Inn, according to the 1844 Charlotte Business Directory. All three of those taverns were close to the courthouse, just as Captain Jack's tavern had been many years before.

The Central Hotel was considered to be one of the finest hotels between Richmond, Virginia, and Atlanta, Georgia. It was well known for its elegant bar, which attracted Charlotte's elite as well as those coming in off of the railroad. In addition to the bar, the Central Hotel also boasted a billiards room and ballroom.

CHAPTER 2

Pre-Prohibition Agencies, Bottlers and Breweries

Very little was written about beer in Charlotte prior to prohibition, but city directories often listed beer-related establishments as beer agencies, bottlers or breweries. The problem with this approach is that often a business would be listed under all three (or more) categories, which makes it difficult to discern exactly what each one did. For instance, the Augusta Brewing Company is listed in three sections of *Maloney's Charlotte 1897–98 City Directory*: "beer agents," "bottling works" and "breweries." Listed in another directory at the same address (207 South College Street) years later as beer wholesalers are "McWhirter W.C." and "Hoster Brewing Co." That Augusta Brewing was listed at that same address suggests that it, too, was only sold in Charlotte and seemed to have no actual presence in the city outside of that. Bill Baab, who wrote extensively about the brewery and interviewed relatives of the brewery's founders, told me he never came across a Charlotte connection. Augusta Brewing did, however, sell a beer named Belle of Carolina, which was likely a rebranded version of its Belle of Georgia meant to appeal to Carolinians.

Thanks to the beer wholesalers, Charlotte had access to a variety of beers from states along the East Coast, though one state's beer stands out in particular. Many ads in Charlotte city directories and newspapers advertised "Philadelphia beer," as if Mecklenburgers had some kinship with the city Captain Jack rode to one hundred years before. The term was used as early as 1832, when William Hunter and Company advertised "Philadelphia beer, Porter on draft and in Bottles." Bergner and Engel Brewing Company,

a popular Philadelphia brewery, was listed in the *City Directory of Charlotte 1884–85* under the section "Beer Agencies." In 1878, Bergner and Engel was one of the largest breweries in the nation.

F.C. MUNZLER'S BEER GARDEN

In 1880, seven thousand people called Charlotte home. At that time, the city boasted seventeen saloons and a beer garden. That beer garden, according to the Charles Emerson and Company's *Charlotte City Directory* for that year, was located at the corner of Trade and Boundary Avenue. This beer garden was owned by one F.C. Munzler ("F" standing for Frederick), and clear bottles with Munzler's name and "Charlotte, NC" are still bought and sold by breweriana collectors, though they are rare. It appears that F.C. Munzler both operated the beer garden and bottled beer on site.

From descriptions of other beer gardens of the time, it seems F.C. Munzler's place would likely resemble what we still know as a beer garden, which is to say it likely offered an attractive spot outside in which to drink beer. Whereas taverns catered to the average workingman, the beer garden was a family-friendly establishment. As Christine Sismondo notes in *America Walks Into a Bar: A Spirited History of Taverns and Saloons, Speakeasies and Grog Shops*, these establishments often contained no garden at all but were instead large indoor halls with long, wooden tables at which families could eat and drink. For the most part, these beer gardens were quiet, but the larger ones "featured shooting galleries, live classical music, and bowling alleys."

The only other reference to a Fred Munzler I could find was in the May 27, 1911 issue of the *Charlotte News*, which notes the death of Rena Munzler, daughter of Mr. and Mrs. Fred Munzler. Her father, who was a member of Charlotte's police department, had passed away some years before.

THE ROBERT PORTNER BREWING COMPANY

Many techniques that we associate with modern brewing came into practice during and after America's Industrial Revolution, including commercial refrigeration, bottling lines, pasteurization and railway distribution. Charlotte had long been situated at the intersection of several trading paths,

so it only made sense that the city would serve as a distribution arm for beer when the railway came to town.

Charlotte's largest pre-prohibition beer bastion came via the Robert Portner Brewing Company, which was first established in Alexandria, Virginia, in 1869. After establishing three distribution branches or "depots" in Virginia, the Robert Portner Brewing Company then moved south into the Carolinas. By 1886, Robert Portner had established depots in Raleigh, Goldsboro and Charlotte (317 South College Street).

The Charlotte depot was not a brewery but a bottling plant that bottled and distributed beer that had been brewed at the Alexandria brewery. Charlotte's location in the middle of the state and its accessibility by railroad made it a prime location for a bottling depot. Most of the Portner depots were also located on railroads, and each included an office, a cold storage room and a stable and wagon shed. Because the Charleston depot did not include a bottling plant, the Charlotte depot would send bottles and kegs to Charleston via insulated and refrigerated railroad cars.

While it's not clear exactly which brands the Charlotte bottling depot handled, it's likely it bottled and distributed most if not all of Portner's offerings. Throughout the years, the Robert Portner Brewing Company was well known for its Virginia Extra Pale Export Lager, Tivoli Cabinet (later Tivoli Royal), Tivoli Select, Tivoli-Hofbrau and Tivolia-Extra. A bock was advertised in Charlotte from 1891 to 1893.

The Charlotte depot was managed by Robert Portner's brother-in-law, Christian (von) Valaer. In the mid-1880s, Valaer was invited to buy a share in the company and take a seat on the board of directors, which was reserved for Portner's best employees. By the mid-1890s, the Robert Portner Brewing Company was said to be the largest beer producer in the South. This success would not last forever, however, as small breweries across the nation faced the threat of larger breweries as well as prohibition.

Robert Portner and Christian Valaer were no strangers to prohibition. Even before Mecklenburg County went dry in 1905, the brewery attempted to get around South Carolina's dispensary laws of 1892–93. These laws required that alcohol be distributed by the state through county dispensaries, which effectively meant that the state was the sole purchaser of any imported beers, such as those brewed by the Portner Brewing Company. The new laws also required that manufacturers purchase their materials in the state of South Carolina.

In open defiance of the law, Portner and Valaer sent a single barrel from Charlotte to the Charleston depot. Employees from the Robert

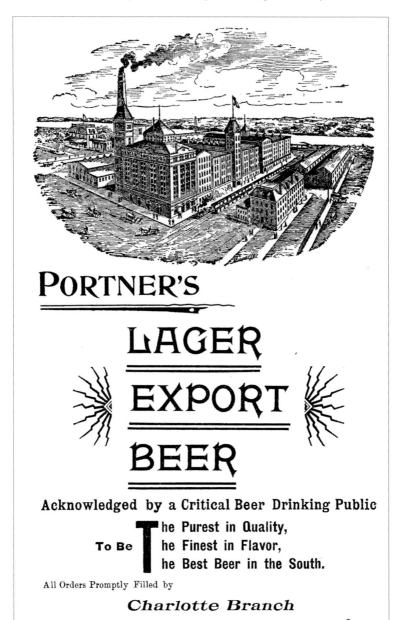

This 1899 ad contains a drawing of Robert Portner Brewing Company's headquarters in Alexandria, Virginia, but notes that orders are filled at the Charlotte bottling plant. *Courtesy of the Robinson-Spangler Carolina Room of the Charlotte Mecklenburg Library.*

Portner Brewing Company put the keg on ice out in the open. This was the first shot fired in a series of battles between the brewery and the state of South Carolina.

Perhaps it's not surprising, then, that Valaer continued to take orders for beer after Mecklenburg County went dry in 1905. To his credit, he stopped bottling beer and instead sent his orders to the Alexandria brewery, which then shipped the beer back to the Charlotte depot. In the end, the brewery had to shut down its Charleston depot after just two years of operation.

Despite his attempt at circumnavigating the authorities in both North and South Carolina, Valaer helped the Charlotte location survive longer through prohibition than many of the other Portner depots and breweries in the Southeast. When prohibition actually went into effect in Mecklenburg County in 1905, Valaer took ownership of the depot he had managed since 1889. Prior to prohibition, competition from breweries led to both lower prices and lower profits. By the time North Carolina declared prohibition in 1908, the Robert Portner Brewing Company had pulled its Virginia depots in Charlottesville, Lynchburg and Fredericksburg. The company also shut down its depots in Georgia and the Carolinas, leaving only the Charlotte depot to serve as a distributor of malt extract, mineral water, ginger ale and sodas.

After seeing states go dry and knowing more would follow, Portner had already started marketing two near beer alternatives when Mecklenburg County went dry in 1905. Amberine and Small Brew were both under 2 percent alcohol by volume (ABV). In the next year, it also introduced Yellow Ade, which was 1.75 percent ABV. These were often labeled as products of C. Valaer Bottling Works or Portner Malt Extract Company. The company even bottled Mayfield's Celery-Cola, which the Pure Food and Drug Administration in 1910 prosecuted for having unhealthful amounts of cocaine and caffeine.

CHAPTER 3
The Temperance Movement and the Anti-Saloon League

S ome may have found beer gardens like F.C. Munzler's to be family friendly but not all. Temperance societies were springing up in cities all over the nation, and Charlotte was no exception. The earliest temperance society in Charlotte was formed in 1820 and lasted until 1836; in 1842, the Washington Temperance Society of Mecklenburg County was formed with an initial membership of 145 people.

The temperance movement started gaining ground following the publishing of Benjamin Rush's *An Inquiry Into the Effects of Ardent Spirits Upon the Human Body and Mind* in 1784. In it, Rush wrote about the many ways that the consumption of alcohol contributed to societal ills like swearing, fighting, a lack of chastity and immoral acts such as "singing, ballooing, roaring, imitating the noises of brute animals, jumping, tearing off clothes, dancing naked, breaking glasses and china, and dashing other articles of household furniture upon the ground, or floor." Rush went on to elaborate on the toll that overconsumption of alcohol took on a person's body and mind.

Just as Rush listed the many symptoms and actions brought about by drunkenness, so too did he rank the harmfulness of alcoholic beverages in one of the book's illustrations, the *Scale of Temperance*. At the top of that scale in the temperance section was spring water, which led to "Health, Riches"; this was followed by milk, which brought about an "Evenness of mind, Reputation." Lest you think Rush is only advocating the benefits of non-alcoholic beverages, read on. After milk comes table beer, which contributes to "longevity and happiness." Below these were cider, perry, porter, ale and

wine, all of which provided "Cheerfulness, strength and Nourishment when used only at meals and in moderation."

Below the temperance section on the scale under "EXCESS" were liquors, punch, toddy, grog, mint juleps, bitters or cocktails, and beside these were listed the various vices, diseases and punishments one could expect upon overindulging (for example: suicide, hemorrhaging from stomach or bowels, and the gallows, respectively).

Further evidence of Rush's defense of beer and moderate consumption can be found in his work's very first sentence: "By ardent spirits, I mean those liquors only which are obtained by distillation from fermented substances of any kind." Later in the text he writes of how nourishing beer can be, and he even goes on to instruct his readers on how to make simple beers using brown sugar, molasses or ginger.

Today we might be inclined to laugh at some of the drunken actions Rush described, but in the eighteenth and nineteenth centuries, alcoholism was a very real problem. Many early temperance societies were formed by women who had seen the effects of alcoholism at home firsthand. Some church leaders were also in favor of temperance and from the pulpit preached their views on the subject.

In 1897, Reverend A.J. McKelway, pastor of the Presbyterian Church of Fayetteville, began campaigning to shut down the dozen saloons that did business in Fayetteville at the time and, with help from other ministers and church officers, he did just that. He and many of his fellow ministers held a conference in Charlotte in hopes of doing the same in Mecklenburg County. They managed to get 3,200 people to sign a petition, which at that time was reported to be the largest petition ever signed in a North Carolina county. McKelway and more than 100 Mecklenburgers accompanied the bill to Raleigh, where it was passed unanimously in the House but defeated in the Senate. McKelway could not in Charlotte accomplish what he had in Fayetteville, perhaps because Charlotte was a larger, more progressive city. Still, he was not defeated: "But the matter has been merely postponed, and it is only a question of time when the saloons in Charlotte and in North Carolina generally will be superseded by dispensaries or closed by prohibition."

THE ANTI-SALOON LEAGUE

While some temperance societies would call for reduced alcohol consumption over abstinence, eventually the movement became synonymous with prohibition. The leading voice for prohibition, though, came when the Anti-Saloon League was formed as a national organization in 1895. On July 5, 1904, an election allowed Mecklenburgers to choose between a local dispensary or prohibition, and the latter was chosen by a majority of 485. Prohibition went into effect in Charlotte on January 1, 1905, fifteen years before the Eighteenth Amendment mandated national Prohibition.

In 1904, the Anti-Saloon League of Charlotte published *A Call to the United States: A Second Mecklenburg Declaration of Independence July 5th, 1904.* The booklet's lengthy subtitle pretty well describes its contents: "It Helps Business and is a Blessing: What Leading Business Men, Bankers, Farmers, Laborers and Others Say About PROHIBITION in Charlotte, N.C."

Six months after Charlotte went dry, many of its outstanding citizens told why the city and its residents were better for it. Employees that would otherwise arrive for work drunk or hungover

> **It Helps Business and is a Blessing**
>
> What Leading Business Men, Bankers, Farmers, Laborers and Others Say About
>
> # PROHIBITION
>
> ### in Charlotte, N. C.
>
>
>
> **Issued by Executive Committee of Anti-Saloon League, of Charlotte, N. C.**

The saloon was voted out of Charlotte on July 5, 1904. In 1908, the Anti-Saloon League of Charlotte published a second edition of the booklet "It Helps Business and Is a Blessing: What Leading Business Men, Bankers, Farmers, Laborers and Others Say about Prohibition in Charlotte, N.C." This work contained accounts of Charlotteans praising the effects of prohibition. *Courtesy of* Documenting the American South, *an online archive from the University of North Carolina at Chapel Hill Library.*

were now sober, and productivity had increased as a result. Many merchants reported better business under prohibition. Crime was down, and women were treated better at home. A.C. Hutchison, secretary and treasurer of Southern Hardware Company, summed it up thusly: "From a business standpoint, I think the town is better off, and from a moral standpoint it is bound to be better."

Many of the comments hint at the racial division present in Charlotte at the turn of the century. H.Q. Alexander, a doctor and representative of Mecklenburg County, stated, "When the saloons were in Charlotte negroes and others would leave the city and on their way home drink and curse to the annoyance of the good citizens." A "splendid farmer," L.H. Robinson, echoed these comments when noting, "On Saturday the negroes would get together and send to Charlotte for liquor, and on Sunday there would be regular rows. Now such conditions do not exist. When we send negroes to Charlotte we have no fear like we once had, that they would come back drunk with something broken or unattended to." There are several more comments much to the same effect.

Under the heading "What a Hard-working Colored Man Says" was Alfred Watson's account of how he was able to sober up and pay back money borrowed on his home: "Prohibition has helped me, and although an humble colored man, I give this testimony." All of these accounts are noteworthy in showing just how divided Charlotte was in terms of race. Many people, especially in the North at the time, felt that prohibition was fueled in the South by whites hoping to keep liquor away from blacks. Many black leaders, though, including Booker T. Washington, felt that prohibition was indeed beneficial to both races.

In the entirety of the thirty-two-page booklet, there is not a single mention made of beer. Instead, the league declares victory over the "saloon system and the liquor habit," citing the closing of many saloons in the area and the emergence of new businesses, such as cotton mills. The word "whiskey" is mentioned seven times, while "liquor" is mentioned eleven. This language seems to reflect the point Benjamin Rush made over a century earlier that people were more concerned over the abuse of liquor than beer.

In 1908, at the request of "many people all over the country," the anti-saloon league published a second-edition of the booklet with an introduction by Heriot Clarkson, the league's chairman. In looking back at the full year under prohibition, Clarkson wrote that there were 909 fewer arrests in 1905 and property value increased 10 to 20 percent. He ended his introduction to the second edition with this: "I hope to live to see the day when the saloon, 'the blot on the garment of our Country,' will be wiped away." That blot would indeed be wiped away, though more than a decade later.

Sodas in North Carolina

The year 1905 was a bad one for beer drinkers in Mecklenburg County, yet that did not stop the Dixie Brew Company from incorporating with $50,000 capital. That bit of information was gleaned from an old volume of *Industrial Refrigeration*, and unfortunately, the only other information I could find regarding the company was in *Walsh's Charlotte, North Carolina, City Directory from 1905–1906*, which states that Dixie Brew Company produced root beer at 9 South Tryon Street.

It is unclear whether this company set out to produce only root beer or if it had to turn to beer alternatives due to prohibition, as so many other breweries did. Of course, if businesses like the Robert Portner Brewing Company and Dixie Brew Company were turning to sodas to stay afloat, then it shouldn't be surprising that the soda industry on the whole also stood to profit from prohibition.

The first Coca-Cola bottled in the Carolinas was sold in Charlotte by J. Luther Snyder in 1902; until that point, it had only been available at soda fountains. When Snyder first opened the Charlotte Coca-Cola Bottling Company, he would ride around the city in a horse and buggy, on the side of which were the words "Drink Coca-Cola in Bottles." Snyder wrote that it was very difficult to sell soda in the city prior to prohibition due to the many saloons in the city: "I had a terrible time selling soft drinks with that kind of competition."

It was quite a different story three years later, when Mecklenburg County went dry and voted the saloon out of Charlotte. As business increased, the Charlotte plant opened up additional locations in Concord, Monroe, Gastonia, Lincolnton, Lexington, Albemarle, Shelby and Salisbury.

Of course, Charlotte wasn't the only southern city developing a thirst for soft drinks, especially in North Carolina. The New Bern, North Carolina company producing Pepsi-Cola trademarked the brand name in 1903 (it had previously sold it as "Brad's Drink"). The Carolina Beverage Corporation, based out of Salisbury, North Carolina, introduced Cheerwine in 1917.

This book is about beer, not soda—and yet the history of those two beverages goes hand in hand in North Carolina, thanks in large part to prohibition.

BOOTLEGGING AND BLIND TIGERS

Not all Mecklenburgers were happy to sip sodas instead of suds. Charlotte was no different than the rest of the country in that people still brewed, bought and sold homebrew illegally during prohibition—Charlotteans just did it years before most of the nation.

One notorious bootlegger, George L. Smith, made a living by operating speakeasies out of stores or billiard rooms around the state. After being caught many times doing just that, he moved to a dry Charlotte in 1905 and wasted no time in setting himself up for business:

> *I then went up town and bought a lot of canned goods and two kegs of cider and put in my store. Then I ordered me two cases of whiskey and two barrels of beer. The express wagon delivered it to me at my store. Then I began my blind tiger business in Charlotte, still labeling my beer "Black Brew Tonic." I sold here for about two months, and had a good trade, selling about five cases of whiskey and from five to seven barrels of beer a week. The last Saturday I was in town I sold two cases of whiskey and about three barrels of beer. I could have sold more if I had had it.*

After dinner one night, someone told George the police were after him. He took the first train north to Statesville, where the next morning he asked the mayor if he could sell his Black Brew Tonic in town. The mayor, who had seen George's name in the paper twenty-five times as a blind tiger dealer, told him to catch the next train out of town. He did.

After bouncing around doing much of the same in cities across the state, he found his way back to Charlotte in 1907. He operated a blind tiger for about five weeks before being caught and leaving town again. All told, George would be run out of towns sixty-four times and locked up 208 times.

Many argued that prohibition was fueled in the south by a desire to suppress African Americans. In *Wicked Charlotte: The Sordid Side of the Queen City*, Stephanie Burt Williams suggests that it actually had the opposite effect in that blacks now drank with whites and men with women: "Speakeasies were also a great equalizer. Although there were of course different 'grades' of speakeasies (from posh back rooms with private bands and comfortable booths to a shanty shack on a country road with mason jars for glasses and whatever entertainment happened to walk in the door), the crowds were united by their quest for illegal liquor."

A History of Brewing in the Queen City

And liquor was usually the drink of choice, though people were drinking beer illegally too, as George Smith's Black Brew Tonic shows. The *Charlotte Observer*'s archives yield two humorous accounts in which officers busted illegal beer-making operations. In 1926, two prohibition agents raided a distilling operation in the Newell area of Charlotte (near University City) and found a "120-gallon still, 7,000 gallons of beers, seven gallons of liquor and a complete steam distillery outfit and all the paraphernalia for manufacturing whisky and beer." The agents happened upon three men cooking their breakfast and then ended up finishing that very breakfast when the men ran off.

In 1931, officers found sixty gallons of homebrew in the bathtub of an empty apartment on East Fifth Street. Twelve five-gallon malt cans and a half sack of sugar were also found in the apartment. The men who brewed the beer had apparently been drinking it, and for some unreported reason, the officers felt they were going to bathe in it during the hot weather.

This sort of illegal activity was happening in Charlotte long before national prohibition started in 1920, and it lasted long after national prohibition ended in 1933. States and counties were given the local option to decide if they wanted to maintain prohibition, and Mecklenburg County remained dry until 1947, when seven ABC stores were opened in the county.

CHAPTER 4
Post-Prohibition Brewing in Charlotte

The Atlanta City Brewing Company was incorporated in 1876 in Atlanta, Georgia. The original brewery's wooden building and all of the equipment inside burned four years later in 1880, but the company rebuilt over the original cellars with brick and stone. After getting into the business of selling ice, the company changed its name to the Atlantic Brewing and Ice Company in 1892.

Selling ice was not uncommon among breweries, which also leveraged their cold storage, bottling lines and distribution network to market things like sodas, malt extract, cheeses and more. D.G. Yuengling and Son, this country's oldest operating brewery, even had an ice cream facility that allowed it to stay in business through prohibition. Atlantic also used its network of ice plants to help farmers store meat or crops, and it contributed ice to railroad cars so that such produce could be preserved during its shipment.

When prohibition rendered it completely unable to brew and distribute beer, the company again changed its name to Atlanta Ice and Bottling Company and continued to sell ice and cereal beverages that were probably not dissimilar from the near beer that the Robert Portner Brewing Company was also relegated to brewing. The company began brewing beer again once the Twenty-first Amendment repealed prohibition. The Southeastern Brewing Company opened in Chattanooga, Tennessee, in 1933, and in 1935, it purchased Atlanta Ice and Bottling Company and renamed it Atlantic Ice and Coal Company.

A History of Brewing in the Queen City

In addition to the Chattanooga and Atlanta breweries, the company would go on to open breweries in Charlotte and Norfolk, Virginia, (both in 1936) as well as Orlando, Florida (1937). The Charlotte location, which in 1945 listed a capacity of 120,000 barrels, was located at 300 South Graham Street. The large national breweries prospered after prohibition, while the small regional breweries had a harder time. There were few breweries in the South, and the Atlantic Ice and Coal Company was noteworthy in its ability to distribute to most of the region.

Prior to prohibition, the Atlanta Brewing and Ice Company produced a line of Steinerbru beers, and the new company brought that line back. The Chattanooga brewery also began to market a line of Old South beers that included three beers: an ale, a bock and "beer" (a pilsner). In 1936, the company decided to change the name to reflect the Atlantic name, but so as not to confuse those familiar with the Old South line, it implemented transitional branding that featured Atlantic Old South before switching over completely to the Atlantic Ice and Coal Company.

The company changed names several times, but it wasn't done yet. The next year, it started branding beers only with "Atlantic Company." It continued to brew Atlantic Beer, Atlantic Ale and Atlantic Bock, and it also brewed those three styles under the Steinerbru name (it's unclear if these were different beers or the same beers under different labels). It also produced Signal Pale Dry Beer and Signal Draft Beer (in bottles).

The Atlanta and Charlotte locations were the only breweries that had canning lines. The Atlanta brewery modified its bottling line to package cone-top cans, and the Charlotte brewery installed a flat-top canning line that turned out cans of Atlantic Beer and Atlantic Ale in the 1950s.

An April 28, 1949 article in the *Statesville Daily Record* noted that Atlantic's Charlotte location was the only brewery in the Carolinas, and it went on to describe a process that location undertook called "Schweitzer-izing." This was apparently the result of a secret formula and ingredients the company imported from Switzerland. The process's end goal, however, was not to replicate a beer from Switzerland but rather the water from the river Trent, which was so advantageous to brewing that a host of breweries sprung up along its banks in the small English town of Burton-on-Trent.

Despite the company's efforts to recreate the water from the other side of the pond, it made it very clear in its advertising and beer labels that it was "The Beer of the South." Then as now, smaller breweries distinguished themselves from the national brands by marketing themselves as local or regional breweries. Atlantic tried to appeal to the "Old South" sensibility

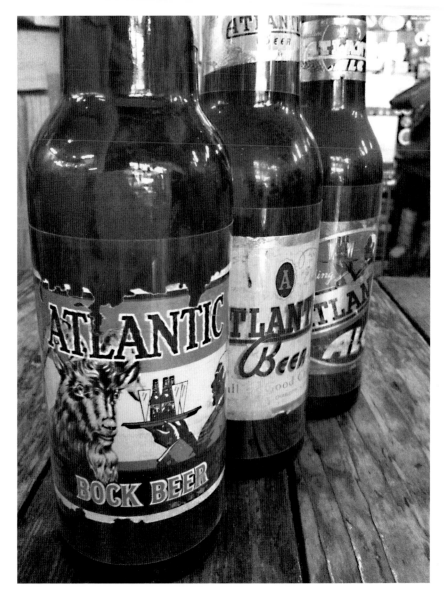

Many of Atlantic Ice and Coal Company's labels featured African American waiters and plantation scenes. *Photo by Daniel Hartis. Collection of Michael Brawley.*

with several labels that featured a black waiter holding a tray of Atlantic beer. The black waiter motif wasn't used only by southern breweries, though. In a 1912 ad for Pabst Blue Ribbon, the text below the black waiter reads: "The waiter knows that he is serving a discriminating guest when ordered to bring

Pabst 'Blue Ribbon' Beer." A 1934 Budweiser ad shows a black man opening a bottle for a white man and the words "Good times coming, boss!" The bock labels featured the same waiter paired with a goat. (The bock style was first brewed in the German town of *Einbeck*; some pronounced this as *ein Bock*, which translates to "a billy goat," and to this day many breweries include images of goats on their bock and doppelbock labels.) Another popular Atlantic label showcased a plantation scene. This scene included a large, southern colonial–style home, in front of which stood southern belles in ball gowns and a horse-drawn carriage.

In these ways, Atlantic sought to set itself apart from the larger brands and appeal to the southern region. And though it was a large regional brewery—the largest in the South at one time—competition from the big breweries eventually forced all of Atlantic's breweries to close down. The original Chattanooga brewery was first to close in 1941, followed by Norfolk in 1949, Orlando in 1954 and Atlanta in 1955. In that same year, the Charlotte brewery was listed as the company's central plant in an issue of the *Statesville Record and Landmark*. All of the company's production was now done in Charlotte, thanks in part to a canning line capable of turning out three cans every second.

A 1955 newspaper ad noted the Charlotte plant's expansion and canning line and also offered a thanks to Carolinians: "During the past 12 months Carolina families enjoyed 17 MILLION cans, bottles and glasses of Atlantic. This great faith of Southern people in their own Southern beer is deeply appreciated."

That faith and the many beers canned in Charlotte and consumed in the Carolinas were not enough to prevent the last location from shutting its doors the next year in 1956. In the end, the Charlotte location was the last of the Atlantic breweries to close, just as the Charlotte depot was Portner Brewing's last stronghold.

CHAPTER 5
Between the Breweries

Homebrewing and Better Beer Bars

D ilworth Brewing, Charlotte's first microbrewery, didn't open its doors until 1989—thirty-three years after the Atlantic Ice and Coal Company shut the doors of its Charlotte brewery. This is not to say there was no brewing presence in the city during that long period. On the contrary, without a brewery in the area, would-be drinkers of craft beer took it upon themselves to brew the beers they so enjoyed.

Roman Davis, the longest-standing member of the Carolina BrewMasters, remembers visiting Jess Faucette's convenience store in 1985 to attend a class on beer tasting, led by Jess's business partner, Mike Waker. Mike grew up in England, and for the tasting, he poured a variety of imports such as Fuller's ESB, for domestic, microbrewed beer was fairly scarce at that time. After the tasting was done, Mike mentioned that he also taught a class on brewing, in case anyone wanted to try to replicate the beers they enjoyed that day. Roman was hooked—Mike's classes set him on a beer-filled journey that continues to this day.

Mike is also credited with convincing Jess to carry homebrewing supplies at his convenience store. At the time, it would have been uncommon to find homebrewing supplies anywhere in the city, let alone in a convenience store. Mike and Jess soon created a homebrewing club called the Alternative Brewers, which was about thirty brewers strong— not a small number in that day. Unfortunately, there was a falling-out between the two business partners. The club was conflicted: Jess owned the business, but Mike had taught them all to brew. The members decided at that point to become an independent club, and so they ditched the

A History of Brewing in the Queen City

Alternative Brewers name in favor of the Carolina BrewMasters title they are known by today.

The club's membership suffered a bit as a result of the disagreement between Jess and Mike. Roman remembers gathering at Dilworth Brewing with no more than five or six members in 1987. The club continued to grow over the years, though, as did the popularity of craft beer and homebrewing in general. Jess and Mike eventually made up, and the Carolina BrewMasters will tell you that Jess and Alternative Beverage have been one of the club's biggest supporters over the years.

For the most part, today the Carolina BrewMasters and all other homebrewers have virtually the same access to ingredients that commercial breweries do, so they can create or recreate any beer they wish. But in the early days of craft beer, the maltsters and hop farmers were focused on fulfilling orders from the country's burgeoning commercial brewers. "When I started brewing, you could have a packet of dried lager yeast, a packet of dried ale yeast and a packet of dried wheat beer yeast," Roman remembered. "You can't produce a lot of styles that way."

As the industry grew, more of the ingredients that had theretofore only been available to microbreweries began to find their way onto the shelves of Alternative Beverage and other homebrewing supply stores. Another boon to homebrewers came in the form of Internet forums and homebrew sites. Today, that's where many homebrewers go to ask questions about ingredients and recipes. Before then, though, homebrewers often had to travel to purchase materials and learn about brewing.

In 1999, the Johnson Beer Company approached the club about partnering to put on a beer festival. More than three hundred people attended the first Charlotte Oktoberfest, which was held later that year in Independence Park. It was a very good showing for the inaugural event, but unfortunately, the festival wouldn't garner the same success in the following year. Due to financial concerns, the Johnson Beer Company was not able to devote much time or resources into the planning of the second festival, so most of this fell to the Carolina BrewMasters. Additionally, poor weather kept many away from Independence Park in the festival's second year.

The festival's popularity continued to grow, and so too did the venues in which it was held. In the years following, Charlotte Oktoberfest venues included: the parking lots of both Southend Brewery and the Rheinland Haus German restaurant; Camden Street in SouthEnd during the Art and Soul Festival; the lot behind the Neighborhood Theatre in NoDa; Memorial Stadium; and the Metrolina Tradeshow Expo. The 2008 festival at Memorial Stadium marked

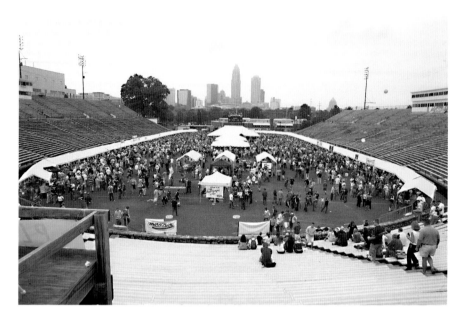

The last time Charlotte Oktoberfest was held at Memorial Stadium was in 2008. A sinkhole beneath the stadium was discovered in 2009, just three months before that year's festival. The festival has been held at the Metrolina Tradeshow Expo every year since. *Photo by Tom Henderson Photography.*

Charlotte Oktoberfest's tenth anniversary. With the city skyline looming above, festival goers sampled beers while listening to Southern Culture on the Skids and other bands. The BrewMasters hoped to repeat this festival's success in 2009, but the discovery of a sinkhole at the location just three months before that year's festival prompted the move to the Metrolina Tradeshow Expo, which has hosted the festival ever since.

By exposing Charlotteans to a wide variety of commercial and homebrewed beers, Roman thinks Charlotte Oktoberfest has played a large part in fostering Charlotte's thirst for craft beer. "If we didn't have a big beer festival here every year," he said, "some of these breweries might not be here in Charlotte today."

BETTER BEER BARS

Those who had no interest in brewing beer were still able to find imports and craft beer around Charlotte in the industry's infancy, though it oftentimes was tough to come by. One of Charlotte's earliest ambassadors for craft beer was

A History of Brewing in the Queen City

Standing Room Only Pub and Deli, whose 1981 beer list featured domestic craft beer like Anchor Steam and Porter, British beers from Samuel Smith's and Belgian offerings from Orval and Lindemans. The bar was managed by Kirk Weaver, who now owns Lebowski's Neighborhood Grill. Standing Room Only boasted around one hundred beers, and Roman remembers a time in which a bottle of each was poured into a large commercial trash can. For five dollars, you could drink from this bucket of blended beers all night.

The cap on beers then was at 6 percent ABV, and yet somehow higher gravity beers found their way into Standing Room Only. "We were getting Liefmans Goudenband in 1984," Roman recalled. "It was illegal at 7 or 8 percent alcohol, but the state didn't know any better. You just didn't find Belgian beers in the United States at the time. They were unique. That would have been an incredible place for craft beer anywhere in the country at that time."

Though it had one of the best selections in Charlotte, Standing Room Only was not the only establishment bringing good beer to the Queen City at that time. Before the Waldhorn, before the Olde Mecklenburg Brewery, there was the Rheinland Haus, Charlotte's first German restaurant. Rheinland Haus opened its doors in the Park Road Shopping Center in 1966 and closed in November 2005, lasting nearly four decades—an eternity when compared with many of Charlotte's short-lived restaurants. The restaurant's beer selection was one of the city's best during most of those forty years but especially during those years in which the Carolina BrewMasters held their meetings there. In 1998, it was serving Highland Brewing's Clawhammer Oktoberfest at its own Oktoberfest celebration. The next year, it was actually serving beers that had been brewed at the Brewing Experience using winning recipes from Carolina BrewMasters members.

Other early establishments for craft beer included Brixx Pizza, Mellow Mushroom and Jonathan's Jazz Cellar, which would later become Atlantic Beer and Ice (and then later still a Fox and Hound, which is what occupies that space today).

The Early '90s Brewing Scene

DILWORTH BREWING

Bob Binnion was in Boston in 1987, waiting for his daughter to give birth to his grandchild, and he needed something to do while waiting for the baby. Little did he know that an idea would be born that day, as on a whim he attended a Brewers Association convention. It was there that he met Chuck Rankin and Phil Hall, two men from Hendersonville, North Carolina, who were interested in opening a brewpub.

A year later, Bob received a call from the two of them to see if he would be interested in investing in the brewpub they planned to open in Charlotte, which they felt was one of the state's best markets for a brewery. At the time, Bob was living in Banner Elk after retiring from the air conditioning business in Philadelphia. He made the drive to Hendersonville to meet with Chuck and Phil, as well as their friend Bill Sides, who would be the brewer. Phil would be the manager, and Chuck would drive down on weekends to help out.

Bob thought it sounded like a promising and fun business plan, so he agreed to invest. In 1989, Dilworth Brewing Company opened its doors at 1301 East Boulevard, where now sits Sutton House (and Picasso's before that. The building also housed Charlotte's first A&P grocery store). It was Charlotte's first microbrewery.

Dilworth Brewing was modeled after an English-style pub, with brass and dark wood in abundance. Behind the bar, a large glass window allowed

patrons a peak at the brewhouse. Over one wall was painted a Mediterranean-style mural of three toga-clad people enjoying beer on a beach. When it first opened its doors, Dilworth Brewing had three beers on tap at the brewpub: Reed's Golden Pilsner, Dilworth Porter and Albemarle Ale, which in 1992 won a bronze medal in the American Pale/Amber Ale category at the Great American Beer Festival in Denver, Colorado.

It would introduce Latta Light and add additional styles in the years to come. Famed beer writer Michael Jackson visited the brewery and praised its scotch ale thusly in a 1994 article in *All About Beer* magazine: "It's very soothing, a very nice example of the style. They're consciously making a more British style of beer, and they're doing a very nice job." The food menu included standard brewpub fare like sandwiches, fish and chips, buffalo wings, nachos and what Michael Brawley (of Brawley's Beverage) remembers as "the best chicken tenders I've ever had."

The food and beer brought many people into Dilworth Brewing, to be sure, but in 1990, Bob reached out to local copywriter Jack Dillard about doing some marketing and advertising for the brewpub. Jack, in turn, came up

This Brew Pub Poets Society logo was used in newspaper ads, newsletters and, of course, *Once Upon A Frothy Brew: The Best of The Brew Pub Poets Society, Volume 1*. Some of the group's print and radio advertising garnered awards and much attention for Dilworth Brewing Company. *Courtesy of Jack Dillard.*

with the idea for the Brew Pub Poets Society. He crafted a carefully worded yet very tongue-in-cheek invitation and sent it out to some of Charlotte's most creative writers, actors, producers, event planners, publishers and radio and TV personalities.

Jack thought it would make for a fun event and bring a lot of people to Dilworth Brewing for the first time, but when thirty-five would-be poets showed up for the first event, the group decided to continue holding meetings on the third Tuesday of each month. To become a member of the Brew Pub Poets Society, all one had to do was write a beer-related poem, bring it to Dilworth Brewing and read it aloud. After doing so, you were a member for life—there was no getting out, even if you wanted to.

The society was patterned after the Algonquin Round Table, that group of New York City writers that gathered at the Algonquin Hotel in the 1920s to share wordplay and witticisms. The Algonquin Round Table boasted legends like Dorothy Parker and Harpo Marx, while the Brew Pub Poets Society included local celebrities like weather anchor Larry Sprinkle and a host of well-known *Observer* columnists, such as humor writer Doug Robarchek, film critic Lawrence Toppman and sports writer Tom Sorensen.

In 1993, Jack published *Once Upon A Frothy Brew: The Best of The Brew Pub Poets Society, Volume 1*. Jack also created some award-winning radio and print advertisements for Dilworth Brewing Company. One of the print ads contains the following poem:

Here's to beer,
that frothy brew,
served in mugs
and schooners, too.
Made from finest
barley malts,
ours has a taste
that has no faults.
Stop by soon
when next you're near,
you look like you
could use a beer.

To this day, Bob says this was the most fun and effective form of marketing the brewery ever did. And while the scribes who gathered there every month had a great time, not everyone in Dilworth Brewing was happy. After a little

more than a year in business, Bill told Bob that he wanted out of the business (perhaps because he felt in over his head, Bob said). Bob purchased his share of the company and allowed him to leave, but it wasn't long before Phil asked out as well.

This left just Bob and Chuck. Bob brought in John Begley, who had experience in the restaurant business, to take over day-to-day operations. John, in turn, hired another John in John McDermott, who had previously brewed at the Mill Bakery, Eatery and Brewery in Charlotte. Though three of Dilworth Brewing's founders would leave Western North Carolina for Charlotte, John McDermott would do just the opposite. He met a man named Oscar Wong in Charlotte who was looking to start a brewery, and at the time, they felt Charlotte could not support another. They left Charlotte for Asheville, where they started Highland Brewing Company in the basement of Barley's Taproom.

In 1993, Dilworth Brewing began sending kegs to Jonathan's Uptown Bar and Restaurant, which was just a couple miles down the road at 330 North Tryon Street. One of the most popular aspects of Jonathan's was the jazz cellar in the building's basement. Soon the brewery began to pick up more accounts, including the Fresh Market, Harper's Restaurant and the Omni Charlotte Hotel. Harris Teeter also sold the brewery's Albemarle Ale in eight stores at a price of $6.79 per six-pack. To keep up with the increase in sales, Dilworth Brewing Company expanded production by opening up another facility on Pressley Road that was used exclusively for brewing.

When Jonathan's went out of business in 1994, NationsBank approached Bob to see if he would be interested in purchasing the three-story building. It offered him a very good price that he was unable to turn down. Bob and his crew soon began remodeling; they continued to use the basement for live music and the main floor as a dining area, while the third floor became a billiards room and cigar bar.

Atlantic Beer and Ice Company opened in November 1995. The name was a nod to Atlantic Ice and Coal Company, which had a brewery in Charlotte from 1936 to 1956. The bar contained a large mural of that brewery's beer, which featured an old South plantation scene. No beer was brewed at Atlantic Beer and Ice Company. Instead, Dilworth Brewing continued to send its beer to the building, where you could also find beer from Johnson Beer Company and Highland Brewing. Atlantic Beer and Ice Company also had a large selection of single malt scotches.

Bob moved to Florida, where he still lives today, and in 1996 transferred ownership of both Dilworth Brewing and Atlantic Beer and Ice to his

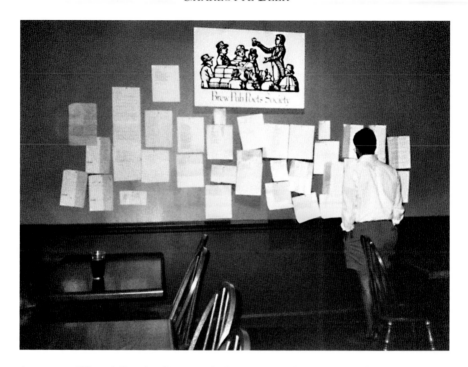

A patron at Dilworth Brewing Company looks over poems brought to the first Brew Pub Poets Society meeting in 1990. *Photo by Mitchell Kearney.*

daughter, Alexa, and her husband, Frank MacPherson. Though Frank would institute many changes after taking over operations of these businesses, parking and a lack of space continued to plague Dilworth Brewing's East Boulevard location. In May 1998, he closed Dilworth Brewing. Atlantic Beer and Ice would make it a few more years before closing in April 2001, when Frank and Alexa closed the business and leased the building to the Fox and Hound Bar and Grille chain, which still leases the building from them today.

Were he to do it all over, Bob says he would insist on having someone familiar with the restaurant industry be among the founding partners of a brewery, as many of their failings early on were on the restaurant side. "One thing I would have done differently would have been to do the distribution ourselves and stay in the Charlotte area," he said. "We probably got a little too ambitious there trying to set up some distribution outside of Charlotte."

Like the men he initially went into business with, Bob soon grew tired of the business. "I only got into it to have a little fun, and it wasn't as fun as I intended," Bob said, laughing. It seems the fun was all on the other side of the bar, as the Brew Pub Poets Society and so many others who spent time in Charlotte's first microbrewery would surely attest.

THE MILL BAKERY, EATERY AND BREWERY

In yeast and grain, beer and bread share a common origin, and nowhere was that more evident than at the Mill Bakery, Eatery and Brewery, which opened in 1990 at 122 West Woodlawn Road. "The Mill," as most referred to it, was a chain, with the Charlotte location being the ninth franchise but the fifth actual brewery (some locations had beer contract brewed for them).

No two locations of the Mill looked the same, since through the company's sustainability initiative it retrofitted existing buildings rather than build new ones. Almost all of the locations, though, featured a few common design elements. Somewhere along the exterior of these buildings was a large water wheel, the kind that in years past would power the riverside mills that would provide grain to brewers and bakers alike. The interiors and exteriors of the Mill locations were typically covered with wood, and most of the brewhouses were surrounded in glass so that patrons could see the brewing process at work. From the road, you could see the J.V. Northwest stainless-steel brewhouse (this equipment was put into storage and just recently purchased by Catawba Valley Brewing Company, which plans to use it in its new Asheville brewery).

Picnic baskets of all shapes and sizes hung from the ceilings. Were they so inclined, customers could purchase these baskets and fill them with a variety of baked goods, including loaves of bread, cookies, cakes, pies, doughnuts and muffins. Oh, the muffins were many! In a 1991 article for the *Charlotte Observer*, Helen Schwab wrote about the Mill's daunting muffin wall the same way Bubba would talk about shrimp years later in *Forrest Gump*: "Granola

After a trip out West, founder Paul Smith opened the Gainesville, Florida location pictured here. It was the fifth of the company's locations but the first to brew on site. The company then became known as the Mill Bakery, Eatery and Brewery instead of the Mill Bakery and Eatery. Most Mill locations used older restaurant sites and, though they varied in appearance, featured a large wagon wheel outside. *Photo by PJ Behr.*

oat bran, apple granola oat bran, oat bran raisin, blueberry oat bran plus chocolate chip, double chocolate chip…the list goes on quite awhile before you get to 'gourmet dessert muffins.'"

Walking down the Mill's cafeteria-style line, you would also find health-conscious meals for lunch or dinner, including sandwiches, salads and pizzas. Many dishes were prepared to meet the American Heart Association's low-fat and low-cholesterol guidelines, and calorie, fat and sodium counts were listed alongside menu items (save for the desserts, conveniently).

The Mill was brewing an Altbier nearly two decades before the Olde Mecklenburg Brewery brewed its first batch of Copper. Hornet Tail Ale was one of the Charlotte location's most popular beers, and fans of that beer could proudly show their love for the beer with a T-shirt bearing the words, "Catch a Buzz." And they had much to be proud of, it seems, as that beer won a silver medal at the Great American Beer Festival in 1990. The winning version of that beer was brewed by John McDermott, also of Dilworth Brewing and Highland Brewing fame. The next year, the Mill's Red October took silver in the Münchner Dunkel category. That one was brewed by Jason McKnight, who started at the Mill as a server before working as a bartender and then finally a brewer. Hornet Tail Ale won again in 1995, though it was under Jason's watch this time.

The recipes Jason used to brew his award-winning beers were the same ones used at other Mill locations, though their names often changed to reflect the city in which they were brewed. Instead of Hornet Tail Ale, a Florida location had Gator Tail Ale; instead of Charlotte's Harvest Gold, they had Seminole Gold. The Mill in Charlotte also brewed a Harvest Gold Light, Wheat Field Dry and McKnight's Stout, which was, of course, named after the brewer.

Though he had kind words for Dilworth Brewing's scotch ale, esteemed beer writer Michael Jackson wasn't as impressed with the Mill's beers as the judges at the Great American Beer Festival were. "They're a bakery and a brewery," he was quoted as saying in an article from *All About Beer* magazine. "I didn't really feel that they took the brewing side of their business terribly seriously."

The Mill closed down and reopened as Carolina Mill Bakery, Eatery and Brewery around 1994, according to Jason McKnight. In 1996, the brewery again closed and reopened, this time as Queen City Bakery and Brewery. I could find no record of that incarnation closing, but a 1997 article in the *Charlotte Observer* shows that a judgment was made that Queen City Bakery and Brewery LLC pay $55,958 to US Foodservice, Inc. It is likely that this had something to do with the establishment's closure, as I can find no record for it after that time.

The Mid-'90s Brewing Scene

JOHNSON BEER COMPANY

When Tim and Susan Johnson were told that the New Orleans–based computer company they were working for was downsizing and that they would be laid off, they decided to build a brewery. Tim learned to homebrew at an early age by watching his father, who would often involve him in the brewing process. His wife, Susan, took classes on brewing in Portland through the University of California–Davis.

With its diverse and business-friendly economy, the Johnsons thought Charlotte would make an ideal home for a microbrewery. The two "threw a dart at the wall," and that dart eventually landed at 2210 South Boulevard in the city's SouthEnd neighborhood. "We put together a business plan, signed the lease on January 1, 1995, and we were brewing beer by March," Tim said. "The whole experience from deciding to quit our jobs to brewing beer was about eight months."

The process moved along quickly thanks to help from some beer industry veterans in the area. Before leaving New Orleans, the Johnsons hired the brewmaster and CEO from Abita Brewing Company as consultants. They left the Big Easy for the Queen City and opened their brewery in 1995.

By March of that year, they were bottling Johnson's Amber Ale. The next year would see the introduction of Johnson's Brown Ale, Johnson's Pilsner

Chickspeare members Amy Arpan and Nicia Carla Moore act out William Shakespeare's *Henry IV* at Johnson Beer Company, a six-pack of the brewery's Oatmeal Stout between them. *Photo by Linda Neal.*

Lager and Johnson's Oatmeal Stout. The brewery's seasonals consisted of Johnson's Springfest, Summerfest, Oktoberfest and Winter Bock. All of these beers were available in bottles as well as on tap around town.

The brewery started shipping beer across North Carolina to Asheville, Raleigh and the Triad area in April 1995. It also started to move into South Carolina and Virginia. Johnson Beer Company focused on distributing to restaurants and supermarkets, and many of its beers could be found in Harris Teeters and other grocery stores (it was fortunate to have distribution with Harris Teeter from day one). The Amber Ale and Brown Ale could be found across the Carolinas and into Virginia. The Springfest seasonal was brewed exclusively for the Charlotte festival of the same name.

In addition to these beers, Johnson Beer Company also contract brewed beer for seventeen different brands. It continued to brew Dilworth Brewing's beers long after it closed so that Atlantic Beer and Ice (now Fox and Hound) could continue to sell its beers. It brewed for the Old North State Winery and Brewery in Mount Airy, North Carolina, and it brewed for Frederick

Brewing Company in Frederick, Maryland. It brewed Abita's Purple Haze for its friends back in New Orleans, and it brewed a Foster's clone called Razor's Edge for Outback Steakhouse. It even contract brewed a single batch of Hauser's Brown Mountain Light Ale for Charlotte's Hauser Brewing Company, which went out of business before it could even buy the beer from the Johnsons.

At the time the Johnsons signed their lease, Dilworth Brewing and the Mill Bakery, Eatery and Brewery were the only two breweries in town. That changed just months after the Johnsons signed the lease on their building. That's when Southend Brewery and Smokehouse came to town.

On August 1, 1997, after being open for three years, Johnson Beer Company offered a public stock offering in an effort to raise $1 million, which it planned to use in its expansion outside of Charlotte. For $200, one could buy one hundred shares of the brewery (this was the minimum amount of shares). It was the first business in North Carolina to conduct a public offering over the Internet, and it ended up raising around $400,000.

In December 1997, the Johnsons relocated the brewery from its home in SouthEnd to a thirty-five-thousand-square-foot building at the intersection of Central Avenue and Hawthorne Lane in Charlotte's Plaza Midwood neighborhood (1109 Central Avenue). The move afforded the brewery a unique identity that it didn't have in SouthEnd.

The new building had housed a variety of businesses since it was built in the 1920s. Its earliest occupant was Pet Dairy Products, which bottled milk and made ice cream in the building. To keep all of that milk and ice cream cool, the building was equipped with coolers, storage rooms and twenty-six-inch-thick brick walls. The tiled floors also had drains already built in. In short, the building had just about everything a brewery needed.

For some time, Johnson Beer Company was the largest craft brewer in North Carolina. In 1997, the company was brewing about twelve thousand barrels of beer a year. The only brewery producing more beer in the Southeast was the Abita Brewing Company, their friends from New Orleans.

The big brewers took note. At one point, Tim thought Anheuser-Busch might be interested in buying the company, but it instead decided to purchase a stake in Seattle's Redhook Ale Brewery. "Back in the '90s, they were talking about the brewing business like people talked about the Internet," Tim said. "If you got into the brewing business, people were going to come. It didn't really work out that way."

The debt continued to build, and though they could have continued to operate, it was clear to Tim that the brewery likely wouldn't grow into the large brand he and his wife had envisioned. In July 2001, Johnson Beer Company closed. Johnson Beer Company's legacy can still be seen today at Charlotte Oktoberfest, which the brewery helped organize with the Carolina BrewMasters in 1999.

SOUTHEND BREWERY AND SMOKEHOUSE

Be they textile, grain or cotton, Charlotte's old mill buildings—few as they may be—are a nod to the city's industrial past, a time before the big banks came to town, when many Charlotteans made their living in places like the Atherton Mill. Built in 1893, Atherton Mill housed five thousand spindles used to turn cotton into yarn; these spindles were operated by three hundred employees, many of whom lived in the mill village. Living so close to the mill provided little respite for the men, women and children that worked at Atherton Mill, often for twelve hours each day. In addition to houses for employees, the mill also contained a general store, town hall, school and Sunday school. When it was first built, Atherton Mill lacked indoor toilets and hot water. The work could prove dangerous, as evidenced by the many newspaper accounts of injuries, fatalities and fires at the mill.

Suffice it to say, quite a lot of history happened in Atherton Mill. When Southend Brewery and Smokehouse began its million-dollar renovation on the building in 1995, it wanted to preserve as much of the century-old building's past as possible. One of the first steps in the renovation was to pull back the building's metal siding. Doing so revealed the Atherton Mill's original stucco, which was soon restored and recoated a beige color. The small windows that once afforded mill employees with natural light and fresh air were cut deeper to allow for greater views into and out of the brewery and restaurant. A tall silver tank emblazoned with Southend Brewery's logo stood outside the building, and inside, the building's industrial past could be seen in its exposed ductwork and twenty-five-foot ceilings that reached to heavy metal beams. Helping to marry this old aesthetic with a more modern one were custom lighting, rich wood and old gold paint, perhaps a nod to Charlotte's gold rush past.

History has a way of repeating itself, and the buildings that once housed mill employees were soon converted into the Atherton Lofts at Atherton

Mill, a complex of condominiums constructed with as much care for the building's history as was used in the renovations at Southend Brewery. The brewery was one of the first attempts at revitalizing Charlotte's SouthEnd, and it was undertaken by Joe Ryan, president of Carolina Brewing Group Inc. (the name given to the Southend investors partnership). "Charlotte's not a really old town, and we wanted something we could renovate and rejuvenate," Joe said.

One of Joe's partners in the Carolina Brewing Group was Rao Palamand, with whom he worked while at Anheuser-Busch. Joe was a quality assurance specialist at Anheuser-Busch in Williamsburg, Virginia, before the position took him to California and then New Jersey for eighteen years. Rao served as director of product development and helped that company introduce brands like Bud Light, Natural Light and O'Doul's nonalcoholic beer. He was living in St. Louis at the time but spent much time getting Southend Brewery set up and training its brewers. Joe and Rao worked at one of Anheuser-Busch's wineries together, where Rao would blend wines and work with other non-beer products. When years later Joe decided to move from New Jersey to Charlotte to open a brewery, he knew he wanted to involve Rao, who was one of the company's leading product development experts.

Rao was responsible for designing the Southend Brewery's initial lineup of beers, which included Carolina Blonde, Joe's Red Ale, Rudy's Chocolate Ale, Friar Tuck's Oatmeal Stout and Bombay Pale Ale, a reference to the city in which Rao was born.

Southend Brewery was just a couple doors down from Johnson Beer Company, which had opened earlier that same year. The two breweries displayed different approaches to the business: the Johnsons focused only on beer, which they bottled and distributed throughout the city, but for Southend, brewing was only part of the equation. Just as popular as its beer was its food, which included salads, sandwiches, nachos, wood-oven pizzas, barbecue and smoked ribs.

The beer, food and hip environment brought many into the brewery, including some of Charlotte's most famous residents. "Nature Boy" Ric Flair was a regular, as were members of the Charlotte Hornets and the Carolina Panthers, which began life as a franchise in 1995, the same year Southend Brewery opened in Charlotte. Mark Richardson, son of Carolina Panthers owner Jerry Richardson, was a founding partner. "Quite a few Carolina Panthers players would come in after home games," Joe said. "They were great with the crowd. They would sign autographs, and then the crowd would let them get something to eat. It was really something."

Other famous visitors—including Rod Stewart, James Worthy and Michael Jordan (not yet the owner of the Charlotte Bobcats)—would autograph menus, which were then framed and hung on the brewery's walls. In the same building in which so many spent long days working more than a century ago, millionaire athletes and Average Joes alike would get together for drinks and dinner.

Some of those people would arrive at Southend Brewery via the Charlotte trolley, which went as far south as the Atherton Mill market and as far north as Stonewall Street downtown. Charlotte's streetcars predate even Atherton Mill, though not by much. The trolley barn was located right behind where the mill would be built two years later. As yet another aspect of SouthEnd's revitalization plan, the trolley system was brought back on a trial basis in 1996. It ran only on Thursday and Friday evenings, Saturday nights and Sunday afternoons for the six-month trial period. The trolley proved so popular during that time that it was brought back for a year. Service later returned in 2004 and 2005, though not for long due to construction and the LYNX light rail.

The trolley and old Atherton Mill building weren't Southend Brewery's only historical ties. Southend Brewery opened up a location in a historical district of Charleston, South Carolina, in 1996, just a year after it had opened the Charlotte location. In September 1999, it added two more locations: one in Raleigh and the other in Jacksonville, Florida. It opened a location in Lake Norman in 2000, the same year that Lake Norman Brewing Company closed. The company planned to open a location in Atlanta, Georgia, though it does not seem that one ever opened.

All of these locations were, according to an archive of Southend Brewery's website in 2001, "a sign of the never-ending brewpub craze and, because we offer the finest beer in all the city, the craze continues." That same archive listed a beer lineup that included Southend Light Blonde, Southend Blonde, Ironman Wheat, Motorman's Pale Ale, Olmstead Red, Bank Town Brown and O'Ryan's Oatmeal Stout. As chain breweries are so wont to do, Southend Brewery renamed its red, brown and pale ales in other locations to appeal to residents or tourists in those cities. For instance, Raleigh had a Railroad Red, Charleston had an East Bay Brown and Jacksonville had a First Coast Pale Ale.

Of course, that "brewpub craze" did end, and all of the locations—save for the Charleston one—have since closed. The original Southend Brewery and Smokehouse in Charlotte shut its doors in 2007. Downtown had become much more of a destination than in years past, and due to its size, Southend

Brewery needed to do quite a bit of business to stay afloat. Afterward, the Carolina Beer Company occupied that building with its Woods on South concept, but it closed that down in 2008 after not even a year in business (more on that in the next chapter). In 2010, Icehouse moved into the old Atherton Mill.

CAROLINA BEER COMPANY

When you build a thirty-thousand-square-foot brewery in a five-hundred-acre industrial park, don't be surprised when you get to name the road on which your business sits "Barley Park Lane." Such was the case with Carolina Beer Company, a division of Carolina Beer and Beverage, LLC, which in 1997 became the first business to commit to the newly developed Mooresville Business Park.

Inside the vast, two-story warehouse on Barley Park Lane stood a fifty-barrel brewhouse, ten one-hundred-barrel fermenters and a bottling line capable of cranking out 120,000 bottles each shift. The brewery was founded by president John Stritch and CEO Mike Smith, neither of whom were strangers to bottled beverages. While in college, John drove a Coors delivery truck in Los Angeles. He later became a brewery representative for Coors before becoming a sales manager for the Miller Brewing Company in 1976. After this, he left Los Angeles for Denver, Colorado, where he managed an independent Miller distributor. He moved to Charlotte in the mid-'90s to market Southend Brewery's beers around Charlotte. Mike was an investor in Southend Brewery, and that's how the two met. While Mike had no experience in the beer industry outside of his investment, his father had worked at Sealtest Bottling Corporation before starting a company called Dairy Fresh, Inc., which bottled milk and produced ice cream.

Southend was growing rapidly, and the business was at a point where it had to commit to either being a brewery that distributed beer all over town or a brewery/restaurant that only sold its beer in-house. It chose the latter, and shortly thereafter John and Mike decided to leave Southend and start Carolina Beer Company. For two years, Carolina Beer Company's beer was contract brewed by breweries in Pennsylvania and Greer, South Carolina. The massive Mooresville brewery didn't start producing beer until March 1999. It was instantly the largest brewery in the Carolinas and was ranked number 86 of the country's then 2,500 craft breweries in terms of production.

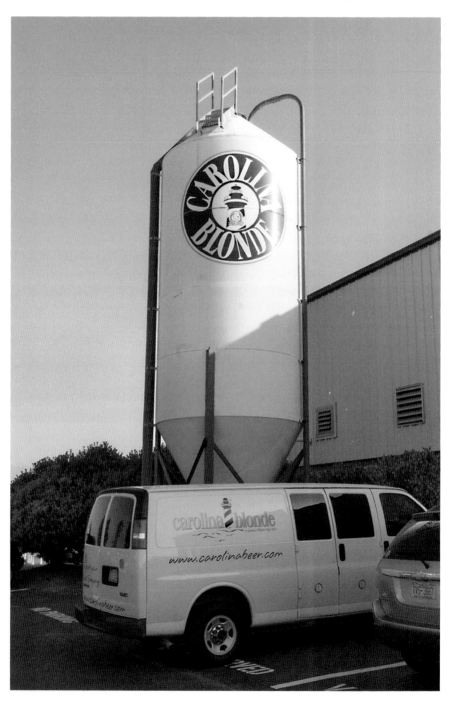

It was hard to ignore the giant Carolina Blonde tank outside of Carolina Beer Company in Mooresville. *Photo by Tom Henderson Photography.*

Perhaps, somehow, you have never heard of this brewing empire to Charlotte's north, but it's nigh impossible that you have never heard of its flagship beer, Carolina Blonde. This very drinkable blonde ale was actually first brewed by Southend Brewery. John felt that the beer was a step up from the domestic light lagers that were and still are so popular, and he could see the potential for it to be a flagship beer. In 1997, he and Mike purchased the Carolina Blonde name and recipe from Southend Brewery. It was a very smart decision, as that beer would later constitute half of the company's beer sales. The next year, it started brewing and bottling it at the large facility on Barley Park Lane. Outside of that warehouse towered a grain silo, and on it was Carolina Blonde's lighthouse logo that would become so familiar not just to beer lovers in the Carolinas but also in Virginia, Tennessee and Georgia.

In addition to Carolina Blonde, John and Mike also developed Carolina Light, Carolina Strawberry and the Charleston Ales line, which included Charleston Wheat, Charleston Pale Ale and Charleston Brown Ale. Charleston was one of the first port cities that the British used to bring beer to the colonies, and much of the beer was sent over in casks that had previously held Sherry wine. As a nod to that history, Carolina Beer Company stored the grain used for the Charleston Ales line in Sherry barrels.

Carolina Blonde was one of Carolina Beer Company's most popular beers. Today, Foothills Brewing in Winston-Salem, North Carolina, produces Carolina Blonde and Carolina Beer's Cottonwood line. *Courtesy of John Phillips and www.microlabelguide.com.*

Carolina Blonde was not the only brand that Carolina Beer Company purchased. In 2000, the company not only bought brands and recipes from Boone's Cottonwood Brewery, but it also hired the man who created them—and with good reason. Don Richardson came to Cottonwood Brewery in 1997 and was immediately tasked with moving all of the equipment to a new location about one mile down the road. While no small task, the process was made easier due to Don's experience working a variety of positions—including brewer—at Boulder Beer Company in Boulder, Colorado.

Cottonwood Brewery and Howard Street Grill reopened in Boone in September 1997, as John and Mike were busy assembling their own brewery. Don set to work brewing a variety of beers in Cottonwood's fifteen-barrel brewhouse, which was markedly smaller than the one on which he had brewed in Boulder. He wasn't a year removed from Colorado and still very new to brewing at Cottonwood when his Low Down Brown Ale was recognized in that state—and nationwide—with a bronze medal at Denver's Great American Beer Festival in 1997. His Horton's Irish Stout took silver the next year in 1998, and his Great Pumpkin Spiced Ale took bronze in 1999. That pumpkin ale also won a silver medal at the 2000 World Beer Cup.

Carolina Beer Company was searching for a brewmaster when it acquired these brands, so it just made sense to bring on the man who had crafted these award-winning beers. The line of Charleston Ales was discontinued not long after the company bought the Cottonwood brand, which was soon distributed to five states. In addition to the aforementioned beers, Don also brought with him his Endo India Pale Ale, Frostbite, Scottish Ale, Red Ale and several others that were brewed on a smaller scale.

Before Carolina Beer Company acquired Cottonwood, Don remembers how much trouble that brewery had selling beer in the Queen City. Raleigh, on the other hand, couldn't get enough Cottonwood. After being acquired by Carolina Beer Company, Don's beers joined Carolina Blonde and Carolina Light's distribution to five states. "It was cool to be able to expand like that," Don said. "It was challenging, but it was exciting."

In 2001, Carolina Beer Company began offering contract packaging services to other brands. Sensing that the brewery was slowly heading away from the beer business, Don left Carolina Beer Company and the Cottonwood brands in 2003. Soon after, he lent his pumpkin prowess in a collaboration with Catawba Valley Brewing Company, and his name still lives on in that brewery's King Don's Original Pumpkin Ale. He started his own company representing a variety of beers called All Good Brands, which he ran for

several years. Today, he is the co-owner and head brewer at Quest Brewing, a brewery in Greenville, South Carolina, that he plans to open in May 2013.

Though it was now bottling soft drinks and other beverages, Carolina Beer Company's beer division continued to grow. It started allowing tours in 2003; for five dollars, you got an hour-long tour and samples of nine beers.

When Southend Brewery closed in 2007, Carolina Beer Company saw a unique opportunity to return to the location where Carolina Blonde was first brewed. It teamed up with celebrity chef Marvin Woods, who was well known for his television show *Home Plate*, and rebranded the location as Woods on South. It was a homecoming of sorts for the chef, who early in his career worked at Southend Brewery. Marvin Woods was one of the first celebrity chefs to come to Charlotte, as this was long before Wolfgang Puck and Emeril Lagasse would have restaurants here. He revamped the menu at Woods on South and spent a couple weeks out of each month overseeing operations at the location.

While the kitchen may have been abuzz, the brewery wasn't—though Carolina Beer Company initially planned to brew at Woods on South, it never did. Instead, it delivered kegs of Carolina Blonde and the Cottonwood line so that patrons could enjoy that beer alongside Marvin Woods's "Carolina Cuisine." Though there were some favorable reviews, the Woods on South concept did not last long: Carolina Beer Company opened the location in October 2007 and closed it in July 2008. Some of the brewing equipment would later find its way to the Olde Mecklenburg Brewery, which would open the next year, and some would later go to Foothills Brewing in Winston-Salem. The last of the equipment from Southend Brewery and Woods on South was sold to NoDa Brewing Company years later.

Carolina Beer Company would eventually sell much more than brewing equipment to Foothills. With the brewing side of business at capacity and the packaging and bottling business continuing to grow—thanks in large part to popular brands like Red Bull and Mike's Hard Lemonade—the company left the beer business and sold all of the Carolina Beer Company brands to Foothills Brewing in February 2011. It was important to John and Mike that consumers still be able to find Carolina Blonde and the Cottonwood brands and that they continue to be brewed to the same standards they had for so many years. Carolina Beverage Group, LLC may have dropped the word "beer" from the company name, but its logo still features a bottle cap with the lighthouse on it, an iconic sight to Carolina beer drinkers past, present and future.

LAKE NORMAN BREWING COMPANY

As a pilot, Raymond Renshaw had witnessed the popularity of brewpubs firsthand as he flew to many cities around the country (not unlike NoDa Brewing's Todd Ford, but more on that later). He thought the concept could work in Charlotte, and after securing around a dozen investors (many of them fellow pilots), Raymond and his team began construction on a new building in Cornelius, just off I-77 at exit 28. This new building—red brick on the outside, oak floors and exposed ceiling beams inside—opened its doors in December 1996.

"I came down while we were still in the construction phase," said Dana Fischer, who took brewing courses at University of California–Davis and worked at two other breweries before becoming the brewmaster at Lake Norman Brewing Company. "I was tasked with designing and building the brewhouse and creating the recipes."

While at University of California–Davis, Dana went through its extensive archive of beer recipes and made photocopies of every single one. The brewhouse featured a used eighteen-barrel AAA brewing system that was encased in glass and visible from everywhere in the restaurant. This included six chrome Grundy tanks that caught the eye of anyone who came into the brewery for dinner or a drink.

On that system, Dana crafted more than thirty beers during his three years at Lake Norman Brewing Company. Many of those were seasonals or one-offs, but the brewery was almost always pouring its core lineup of Ale Yeah! Amber, Summer Wheat, Piedmont Ale, Wildcat Brown Ale and Duke's Plutonium Ale, which was its flagship. The brewery had a partnership with Johnson Beer Company to bottle and distribute Duke's Plutonium Ale across the state. Its name made it especially popular among students at Duke University.

One of the things Dana remembers most vividly is the ten-speed Mack truck that the brewery took to various music festivals and events in Charlotte. The inside contained Grundy tanks filled with beer, as well as seventy or so kegs. All of this fed six or seven taps on the outside, which was wrapped in vinyl displaying the company's logo.

Back at the brewery and restaurant, Lake Norman Brewing Company was developing a loyal group of regulars. "It was like Cheers for the Lake Norman area," said Tara Paster, who served as director of operations at the brewery. "It was just a fun place. It was a really terrific environment for pulling people together."

When Tara interviewed with Ray for the position, she was not a big beer drinker (and still isn't). As part of the process, though, Ray asked that she try a flight of the brewery's core lineup. She liked the wheat most of all. In its day, many were unfamiliar with the styles available at Lake Norman Brewing Company. It often poured flights to help expose people to a variety of styles, just as Ray had for Tara. The brewery also grew hops outside so it could show the flowers firsthand to drinkers at the restaurant, though these hops were not actually used in the beers.

Like Southend Brewery and Smokehouse, which opened a year before it, Lake Norman Brewing Company paired its beers with typical tavern fare, such as steaks and burgers. But what Tara remembers most was neither the food nor the beers but the community. The brewery frequently hosted fundraisers for various charities that included auctions, golf outings and charity runs for bikers. Often the brewery's strong cast of regulars would help out with such events. Of course, Lake Norman Brewing Company also received a fair amount of patronage from those visiting the lake.

Between the outside patio and the dining room, Lake Norman Brewing Company could seat around 230 people. When Tara left the company in 1998, those seats were often filled and sales were up. Concerns about the beer quality, however, began to arise after Dana Fischer left in 1999. The brewery closed in June 2000, just a couple months after Southend Brewery and Smokehouse had opened its Lake Norman location. The building that Raymond Renshaw constructed still stands off exit 28, and though Harvey's in Cornelius lacks a brewery, it does continue to serve craft beer within those red brick walls.

Hops Restaurant Bar and Brewery

With more than seventy locations spread across sixteen states, Hops Restaurant Bar and Brewery was at one time this nation's largest brewpub chain. David Mason and Tom Schelldorf opened the first Hops location in 1989 in a small shopping center in Clearwater, Florida. After seeing initial success, the two spent the next four to five years opening up more Florida locations before embarking on their plan to bring Hops to other states in 1994.

Hops first came to Charlotte in 1996, a year before *Nation's Restaurant News* would list it among the country's "Hot Concepts." There was reason to be

The Hops Restaurant, Bar and Brewery in Matthews is the chain's only location still operating in the Charlotte area and one of only four left in the nation (one in Virginia, two in Colorado). *Photo by Tom Henderson Photography.*

optimistic, as at that time Hops was up to eighteen locations. From 1996 to 1999, five Hops brewpubs came to the Charlotte area. There was one in Pineville on South Boulevard, one in the University of North Carolina–Charlotte area, one near Lake Norman, one in the Park Road Shopping Center and one in Matthews. These are all defunct save for the Matthews location, which has now been open more than fifteen years. It is one of only four remaining Hops locations in the entire nation (there are two in Colorado and one in Virginia).

Hops' history has been a tumultuous one, but if the Matthews location has had one constant over the years, it is in John Bradford, who was hired to be that location's brewer in 1996, prior to it opening, and still holds that title today. Though he worked at some of the other locations throughout the years, he has spent the bulk of his time with Hops in the Matthews location's seven-barrel brewhouse.

John has undoubtedly seen a lot change in his fifteen years with the company, but one area that he has not seen change much is the very beer he brews. While he did convince the brewery early on to move from dry to liquid yeast and from corn syrup to malt, he has for the last decade and a half essentially brewed the same four core beers: Clearwater Light, a light

lager; Lightning Bolt Gold, a lager; Hammerhead Red, an amber ale; and Alligator Ale, a porter. In addition to these, all four Hops locations brew six seasonals a year that rotate out every two months.

John fought tooth-and-nail to add an American Pale Ale to his brewery's portfolio, and he won. It's a minor victory, but one that John takes much pride in since the beers he brews are dictated by "corporate." He recognizes that most of the restaurant's customers aren't chasing big, hoppy IPAs or barrel-aged stouts, but he wishes he could brew occasional small batches of his choice. "It's a fine line between accommodating to beer geeks and running a restaurant," John said. "I personally believe you can do both. Rock Bottom does one-offs and casks. I believe they have twelve beers on tap right now."

If John sticks to his traditional schedule, he may not brew twelve different beers in a year. He is already excited for next year, though, because he and the other Hops have been given the go-ahead to brew a pumpkin ale. He would like to do more one-offs and additional seasonals, even if it's just ten gallons at a time on a pilot system. If he brews anything experimental, it's at home on a pilot system that he fashioned after NoDa Brewing's (they gave him the plans to build a system like the one Chad Henderson uses to produce that brewery's weekly NoDable Series).

As a member of the Carolina BrewMasters, John understands that many are brewing and drinking styles that Hops has never attempted. That's not to say his beer has gone unappreciated among craft beer drinkers. Two of the seasonals he brews for Hops—Flying Squirrel Nut Brown Ale and Winter Pale Ale—won silver medals at the Hickory Hops festival in 2010. The other four beers that round out Hops' seasonal offerings are Oatmeal Stout, Mexican Cerveza, Hang Ten Honeywheat and Hoptoberfest.

All of Hops' beers are brewed true to style and some of the city's least expensive. Mondays through Thursdays, a twelve-ounce draft beer will run you $1.50. Growlers are $9.00 to fill and $4.00 for the glass, and you can even buy kegs of beer there. A five-gallon "Corny" keg containing roughly fifty beers is just $39.99.

Beer selection aside, John also acknowledges that many drinkers would prefer to support a local brewery rather than a chain. While he knows that's a tough mindset to shake, he still maintains that his beer is itself a local product. "The way I look at it is, I'm local," John said. "Everyone who works here is local. My beer is going to be different from the guy's at the Virginia location. The recipe's the same, but the way I brew and manipulate the system is going to result in a different beer."

Many who were familiar with the other long-since-gone Charlotte locations are surprised that the Matthews location is still around, especially since it's only one of four in the nation to make the cut. There was a period when Avado Brands, of which Hops is a wholly owned subsidiary, arranged the sale and leaseback of twenty Hops locations. John thinks that helped the Matthews location stay afloat when others weren't so fortunate.

In the building that once housed the Pineville location is a Hooters, and a similar concept—Bikinis Sports Bar—stands in place of the old University of North Carolina–Charlotte Hops. The short-lived location in the Park Road Shopping Center is still stocked with alcohol, as it's now an ABC store (this building was also the first Amos's location, before it became Amos's Southend). And what was once the Lake Norman location still has "HOP" in the name, though they place an "I" in front of it and push pancakes instead of pints.

Visit any of these today and you're not likely to find any indication that the buildings once housed brewpubs, unless you remember those large, heavy wooden doors that could be found at every Hops location. Swinging those doors open at the Matthews location, however, reveals a restaurant/brewery that appears untouched by time—which is not to say it looks dated. In fact, the building has been well maintained and probably looks much like it did fifteen years ago when it first opened. Neon signs bearing the names of the brewery's beers hang above the bar. These beers can also be found throughout the restaurant on large, bold posters that seem as if they should be advertising the latest action movie, not a light lager.

Drinkers today know such clean-yet-generic décor for what it is: the mark of a chain. You will find similar branding at Rock Bottom Brewery downtown. Amid those "classic" beers brewed at Rock Bottom, however, are the one-offs and small batch beers that John wishes he had the freedom to brew. In the 1990s, Hops benefited from a craft beer revolution that ultimately fizzled out around 2000, both nationally as well as locally in Charlotte. The existing four Hops locations have weathered the storm to see another craft beer renaissance, but will they take the steps necessary to embrace this movement while staying true to their roots as a casual restaurant that focuses first on food?

Judging by the restaurant's history for the past fifteen years, it's not likely things at the Matthews location will change soon—but you have to raise a glass to the Matthews location's longevity and to John Bradford for his fifteen years as a brewer there.

Rock Bottom Restaurant and Brewery

Rock Bottom Restaurant and Brewery came to downtown Charlotte in 1997, the same year fellow chain brewpub and competitor Hops Restaurant Bar and Brewery began opening up locations around the city. At that time, downtown nightlife was almost nonexistent, with most leaving the city proper the second the clock struck 5:00 p.m.

Tennessee-based Big River Breweries hoped to change that when it leased eleven thousand square feet on the Transamerica Square building's first floor at 400 North Tryon Street, right across the corner from where Atlantic Beer and Ice once stood (it's now a Fox and Hound Bar and Grill, another chain concept).

So, how does that Big River name fit into all of this? Grab a beer and settle in—even Dale Nelson, the Charlotte location's general manager, admits that ownership of the location has been about as dramatic as an episode of *Days of Our Lives.*

Big River was initially founded in 1992 as Trolley Barn Breweries, Inc. The next year, it opened the first Big River Grille and Brewing Works in Chattanooga, Tennessee. Over the next few years, it would open up several more Big River locations, until Rock Bottom acquired a 50 percent stake in Trolley Barn in 1996. It would then continue opening up Rock Bottom locations—including Charlotte's in 1997—but as subsidiaries of Big River. This means that, even though the Charlotte restaurant and brewery was clearly labeled as a Rock Bottom, it was under the Big River corporate structure and used its beer and food menus.

Though most of the recipes were the same across Big River locations, they were renamed to reflect that city and its history. This is why the Charlotte Rock Bottom's lineup included a Prospector Pilsner harkening back to Charlotte's gold rush past (remember Dilworth's Reed's Golden Pilsner?); a Randolph's Ride Red in honor of George Randolph Scott, a famous actor of the 1920s and 1930s who was raised in Charlotte; and, of course, the very popular Stingin' Brits IPA, which was named after General Cornwallis reportedly called Charlotte "a hornet's nest of rebellion" after leaving the city in 1780. The Battle of Charlotte was fought at the Mecklenburg County Courthouse, just three blocks away from Rock Bottom, where now sits the Bank of America building.

In November 1998, Big River bought back its stock from Rock Bottom. Of course, the Charlotte location was already branded as a Rock Bottom and continued to operate as a hybrid of sorts, taking the branding from

Rock Bottom and the menu from Big River. In 1999, Big River acquired Gordon Biersch Brewery Restaurant Group. Most people familiar with those names think it was the other way around, that the larger Gordon Biersch purchased Big River, but "in this case, the little guy bought the big guy," said Nelson. More than a decade later, in 2010, Rock Bottom Restaurants and Gordon Biersch combined to form CraftWorks Restaurants and Breweries, Inc., a conglomerate that included those two brands as well as Big River; A1A Ale Works; ChopHouse and Brewery; and several more brewery or restaurant concepts. CraftWorks even acquired P.F. Chang's in May through Centerbridge Partners, its private equity firm.

Since it is now truly under Rock Bottom's corporate structure, the Charlotte location must adhere to the corporate menu, which includes an IPA, a Kölsch, a red ale, a rotating "specialty dark" beer, a white ale and the Winter Tartan Ale, its winter seasonal. It will continue to brew Charlotte staples like the Stingin' Brits IPA and the Sweet Magnolia Brown Ale, which won a gold medal at the 1998 Great American Beer Festival in Denver, Colorado.

Though he has to brew these beers, head brewer Evan Carroll is also given freedom to brew a "Brewmaster's Choice," as well as create several other one-offs throughout the year. Rock Bottom frequently does firkin tappings for one-offs and seasonals, and it always donates a portion of the proceeds from these tapping parties to local charities. The Charlotte location also holds several brewer's dinners throughout the year in which it pairs its beers with its made-from-scratch food.

General manager Dale Nelson says that he will put his beer up against anyone's, but he does concede that many people prefer to support local, independent breweries. Recently, a gentleman came in and asked if the brewery was a chain. After Dale answered in the affirmative, the man and his wife turned to leave. "We may be a chain, but our food is from scratch, and our beer is from scratch," Dale told the man. "Give us a shot!" The man did.

In 2012, the Charlotte Rock Bottom celebrated its fifteenth anniversary with a '90s-themed anniversary party in which a DJ played '90s hits while patrons dined on items from the original 1997 menu—at 1997 prices. Evan brewed an American pale ale for the occasion, and a portion of the proceeds from the event benefited the city's Second Harvest Food Bank.

The brewery looks very different now than it did when it first opened back in 1997. In May and June 2012, the Charlotte location underwent a renovation that included new exterior awnings, a more modern bar, garage

Birdsong Brewing's head brewer Conor Robinson built the sign that hangs outside the brewery's taproom in Charlotte's NoDa neighborhood. *Photo by Eric Gaddy.*

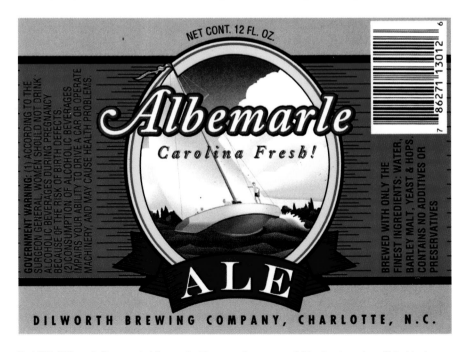

In 1992, Dilworth Brewery's Albemarle Ale won a bronze medal in the American Pale/Amber Ale category at the Great American Beer Festival in Denver, Colorado. *Courtesy of John Phillips and www.microlabelguide.com.*

Lake Norman Brewing Company's Duke's Plutonium Ale, one of the brewery's most popular beers, was named after the nearby Duke Power plant. *Courtesy of John Phillips and www.microlabelguide.com.*

Becca Blanchard pours a pint of the Olde Mecklenburg Brewery's Mecktoberfest, which won a silver medal in the "German-Style Marzen" category at the 2012 Great American Beer Festival in Denver, Colorado. *Photo by Eric Gaddy.*

Three of Birdsong Brewing's owners—Chris Goulet, Tom Gillam and Chandra Torrence—enjoy beers at the taproom in NoDa. *Photo by Eric Gaddy.*

You can find Copper in the Olde Mecklenburg Brewery's taproom, and you can find copper in their brewery. *Photo by Eric Gaddy.*

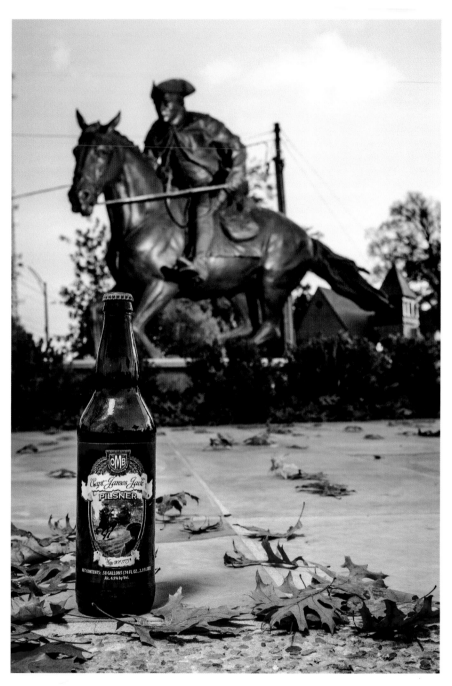

A bottle of the Olde Mecklenburg's Captain James Jack Pilsner stands in front of the statue of the man it is named after. Captain James Jack, who delivered the Mecklenburg Declaration of Independence to Philadelphia in 1775, owned a tavern in Charlotte. *Photo by Eric Gaddy.*

Those having a meal at Heist Brewery will find this view through a large glass wall separating the restaurant and the brewhouse. *Photo by Eric Gaddy.*

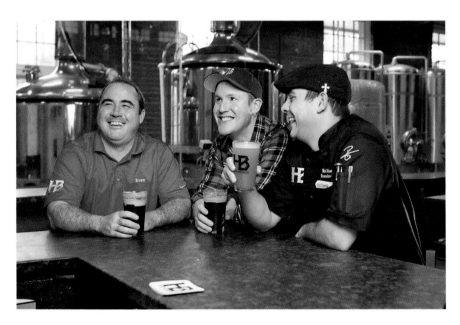

Brewmaster Zach Hart, founder Kurt Hogan and chef Rob Masone take time out of their respective duties to share beers and laughs at Heist Brewery. *Photo by Eric Gaddy.*

Birdsong Brewing's Up on the Sun Saison catches the light in the brewery's taproom, located in Charlotte's NoDa neighborhood. *Photo by Eric Gaddy.*

NoDa Brewing's head brewer Chad Henderson (left) and co-owner Todd Ford (right) stand beside the brewery's ever-growing collection of barrels, while Erica Cline peeks out from behind. *Photo by Eric Gaddy.*

NoDa Brewing's pilot system is dwarfed by the tanks behind it, but that doesn't stop head brewer Chad Henderson from brewing small-batch "NoDable Series" beers on it every week. *Photo by Eric Gaddy.*

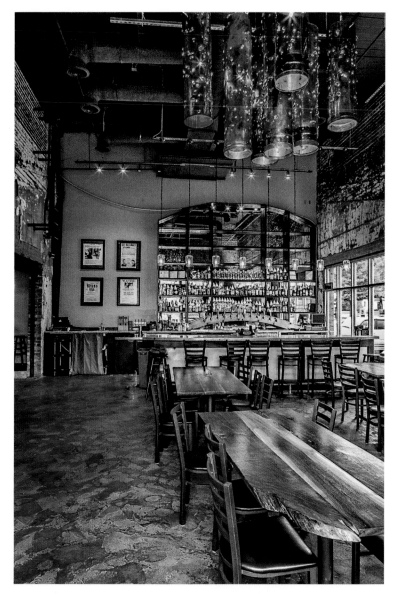

From riddling the copper chandelier with bullets to repurposing wood to build the tables, everyone at Heist Brewery had a part in building Charlotte's newest brewpub. *Photo by Eric Gaddy.*

Right: Though the brewery started out intending to brew only British styles, Four Friends Brewing's most popular beer is their i77 IPA, an American India Pale Ale. *Photo by Eric Gaddy.*

Below: Chris Harker, along with Christina and Chris Muphy (not pictured), are the "three Cs" for which the brewery was named. Triple C Brewing opened in August 2012. *Photo by Eric Gaddy.*

During the fall, the Olde Mecklenburg Brewery's tap lineup includes the popular Mecktoberfest, which won a silver medal at the 2012 Great American Beer Festival in Denver, Colorado. *Photo by Eric Gaddy.*

Sutton House now occupies the East Boulevard building that once housed Dilworth Brewing, though a sign above the door reminds visitors of its brewing heritage. *Photo by Daniel Hartis.*

Matt Glidden's mortgage office shares space with Ass Clown Brewing in Cornelius, North Carolina, but on Saturday nights such as this it more resembles the latter. *Photo by Eric Gaddy.*

Lest the sign on the door reading "Interesting Mortgages" confuse you, a branded barrel greets you on entering Ass Clown Brewing Company. *Photo by Eric Gaddy.*

Toasting NoDa Brewing's first tasting in April 2011 at Duckworth's on Park Road are (from left to right) Chad Henderson, Suzie Ford, Courtney Valvo, Erica Cline, Matt Virgil and Todd Ford. *Photo by Tom Henderson Photography.*

Charles Willett, a member of the Carolina BrewMasters and the Charlotte Beer Club, with a few bottles of Four Friends Brewing's beers during a grand-opening week event in 2010. *Photo by Tom Henderson Photography.*

The Charlotte Beer Girls are a mainstay at Charlotte Oktoberfest, where they pose with festival goers to raise donations for charities each year. *Courtesy of the Charlotte Beer Girls.*

Brawley's Beverage has been a Charlotte beer institution since 2003, two years before owner Michael Brawley would join the fight to "pop the cap." Until that legislation passed in 2005, Michael Brawley could only sell beers weighing in at 6 percent ABV or less. *Photo by Daniel Hartis.*

Seven breweries call the Charlotte area home (nine if you include national chains Hops and Rock Bottom, whose glasses are not pictured here). *Photo by Eric Gaddy.*

Chickspeare, an all-female theater company, performed at Johnson Beer Company in the late '90s. They got the band back together in September 2012 for performances of *Reduced Shakespeare Company's Complete Works of William Shakespeare Abridged* at NoDa Brewing. *Photo by Anthony Proctor.*

Above: The Olde Mecklenburg Brewery's first-annual Copper Classic in 2010 brought many out for a "1,000 yard dash, walk, crawl, whatever for charity." Every year, a portion of the Copper Classic's proceeds goes to Pints for Prostates, which is based in Charlotte. *Courtesy of John Marrino.*

Right: Jon Fulcher pours a pint of i77 IPA at the brewery's taproom and brewery in Charlotte. *Photo by Eric Gaddy.*

doors that open to an updated patio, and artwork showcasing its core beers. A new digital beer board lists not only which beers are on tap but also the date they were tapped, as well as brief descriptions of the beers and their original gravity, ABV and IBU (international bittering units, or a measurement of the beer's bitterness). Rock Bottom also added guest taps, which were filled by NoDa Brewing and the Olde Mecklenburg Brewery after the remodel.

Rock Bottom has never been a locally owned brewery—as its history of partnerships, ownership changes and acquisitions clearly shows—but the Charlotte location's staff still takes great pride in producing made-from-scratch food and beer locally.

THE BREWING EXPERIENCE

In May 1998, Scott Saffer opened the doors to the Brewing Experience, North Carolina's first brew-on-premise location. In a 2,600-square-foot building in Charlotte's SouthEnd (at 1411 South Tryon, which currently houses Tavern on the Tracks), Saffer offered would-be brewers the chance to brew seventy types of beer. You didn't have to know anything of the brewing process or even the difference between hops and malt to brew, bottle and label your own beer—nor did you have to clean up when you were done. It cost about $140 to brew a twelve-gallon batch, but many people were happy to do this for special occasions, such as football games, private parties, company functions or wedding receptions.

Saffer marketed the Brewing Experience not as a way to make inexpensive beer but as entertainment. He likened it to a hobby shop and noted that brewing beer at the Brewing Experience was similar to "calling to reserve a racquetball court."

At the brewery, patrons would be guided through the entire brewing process by a "brew coach." After choosing a recipe, the brew coach would help them gather their ingredients. A row of bins housed specialty grains, large barrels contained liquid malt extract and a cooler kept the yeast and hops fresh. The brew coach would then fill a kettle with sixty liters of water and guide the patron through various additions needed to brew beer.

Afterward, the beer was stored in the Brewing Experience's temperature-controlled fermentation rooms for a week, and then it went into a cold storage for another week after that. Once these two weeks had passed, patrons would return to the brewery to bottle their beers using the forced-air

bottling machines. The facility had the capacity to brew six batches of beer every two hours.

At the time Saffer established the Brewing Experience, forty do-it-yourself breweries existed in the United States. The first brew-on-premise location was established in 1993, according to a 1997 article in *All About Beer* magazine. In that article, Diana Shellenberger, who wrote a column about brew-on-premise breweries for *The New Brewer*, was quoted as saying, "I had people telling me that after five years, there would be more than 500 of these."

Shellenberger predicted more brew-on-premise locations would open, though not at the rate many initially expected. Saffer opened the Brewing Experience in 1998, five years after the nation's first, but this was not without difficulty. Before opening his doors, Saffer endured a two-year legal fight trying to get a bill through the state legislature that would allow businesses to purchase a permit so they could rent equipment to make alcoholic beverages, which was illegal at the time.

The fight started in 1995, when Saffer sent a letter of appeal to the state legislature. When that request fell on deaf ears, Saffer went to Raleigh to enlist the help of Representative Ed McMahan. McMahan agreed to help Saffer in his campaign and sponsored the bill, which was finally passed and signed by the governor in the summer of 1997. The new law required businesses like the Brewing Experience to purchase a $200 permit in order to rent equipment used in making alcoholic beverages.

Individuals and groups alike would visit the Brewing Experience, but they were not Saffer's only customers. Under the name Charlotte Brewing Company, he also supplied kegs to fifteen restaurants. Saffer contract brewed beer for neighboring SouthEnd restaurants like Jillian's and the Gin Mill, and he brewed the Brixx Red Ale that was served at Brixx Pizza. Jillian's would sometimes go through twenty kegs a week of Saffer's contract brews.

Every month, the Carolina BrewMasters would get together to taste homebrews and declare a winner, which Saffer would then brew and put on tap at Rheinland Haus. This popular German restaurant was one of the first in Charlotte to devote itself to craft beer. The customers at Rheinland Haus enjoyed the beer and, of course, the Carolina BrewMasters were thrilled to see their homebrews available at a local restaurant.

Contract brewing for these restaurants kept the Brewing Experience going longer than it should. The brewery also did well by selling root beer to restaurants and even Charlotte's trolley system, which would sell bottles to

passengers. "If I had to do it all over again, I probably would've just focused on the root beer," Saffer joked.

Even with the additional revenue from contract brewing, though, the Brewing Experience was not able to produce the volume needed to make it a profitable venture. In July 1999, Saffer closed the Brewing Experience's doors and sent his kettles west to a brewery in California. In the end, Saffer spent more time getting the bill passed by the state legislature than he did actually brewing beer. As a result, though, he certainly made his mark on Charlotte's budding beer scene.

CHAPTER 8
Popping the Cap

Until 2005, you could only purchase beers up to 6 percent in alcohol, which was the cap going all the way back to when prohibition was repealed in North Carolina. In the 1930s, there was no demand for a beer over 6 percent ABV, but today it would exclude entire styles from being sold. When was the last time you saw a doppelbock, barleywine, imperial stout or double IPA under 6 percent? Or just about any Belgian beer, for that matter?

Fortunately, those dark days are far behind us, thanks to the Pop the Cap campaign. Beer lovers and representatives from North Carolina breweries joined together to start the campaign, which sought to lift the alcohol cap. It started in February 2003, when thirty-five hopeful beer lovers gathered at *All About Beer* magazine's office in Durham, North Carolina.

In the days and months after, the group would become more of a movement than a campaign. Pop the Cap hired a lobbyist to help overcome resistance from "old-line distributors, neo-Prohibitionist interest groups," the Christian Action League of North Carolina and many people who assumed sales of higher-alcohol beers would lead to increased cases of drunk driving.

The Pop the Cap campaign was spearheaded by Sean Wilson. Years later, Sean would found Durham's Fullsteam Brewery, but not before throwing himself into his work as a co-founder of Pop the Cap and a general ambassador for North Carolina's beer scene.

In Charlotte, the Brixx Pizza at Foxcroft held a fundraiser event where a twenty-dollar donation got you tastes of beers that were not available in North Carolina at the time. It seemed Brixx could get away with pouring

samples of these beers because it was accepting donations, so you weren't actually purchasing the beer itself. The beers at the event included "Flying Dog Gonzo Imperial Porter (a tribute to the late Hunter S. Thompson), Brooklyn Brewery's Monster Ale Barleywine, Spaten Optimator, Victory Hop Devil IPA, Orval Belgian Ale and Sam Smith Imperial Stout," according to Helen Schwab, writer for the *Charlotte Observer.*

The only breweries in town at that time were Rock Bottom and Hops, so there wasn't a local brewery that could help fight on Pop the Cap's behalf. Of course, many breweries have come to Charlotte in recent years. Imagine what current Charlotte-brewed beers we would be without if these breweries were limited to brewing beers no greater than 6 percent ABV?

Fortunately, Charlotte's current breweries never had to consider this, but Michael Brawley certainly did when he founded Brawley's Beverage in 2003. Imagine, if you will, what his selection must have consisted of at that time. The dedicated beer geeks seeking higher-gravity beers couldn't get them at Brawley's, and some would even drive out to Virginia or Georgia, where the limits were higher. Mike was quick to spread the word about Pop the Cap to his patrons, and he started making calls to distributors to ensure he would have access to higher-gravity beers if and when the cap was popped. In 2005, he stocked around 180 different beers, but he planned to add 100 more and even remodeled his beer cave in anticipation of the bill's passage.

It was not in vain. When Governor Mike Easley signed House Bill 392 into law on August 13, 2005—thereby raising the cap from 6 percent to 15 percent ABV—Michael Brawley was ready. Days later, bigger beers began to fly on to—and then off of—the shelves at Brawley's Beverage. Some of the first bottles to come in were from Belgian breweries like Orval, La Chouffe, Rochefort and Chimay, which was very popular among Charlotteans when it first came to town. "Pop the Cap was sold to the legislature as 'gourmet beer,'" said Roman Davis, the longest-standing member of the Carolina BrewMasters. "What better icon than this corked bottle brewed by monks? It was the poster child for why you should pop the cap."

Of course, now you can go into most grocery stores and pick up a bottle of Chimay, but at the time, it was very limited, and there was a huge demand for it and other high-gravity beers. Tryon Distributing of Charlotte had to hire additional drivers and sales managers after sales doubled in the months following the bill's passage. So the next time you're at Brawley's Beverage or other beer stores in Charlotte, give thanks to Pop the Cap and all of those who helped bring so many great beers to the state.

The Breweries Are Back

CANS BAR AND CANTEEN

You take a long pull from your Pabst Blue Ribbon tallboy, set it back down and recommence your game of Tetris, or Ms. Pac-Man, or pinball—take your pick, because this place has them all. A TV at the bar plays *Fast Times at Ridgemont High*, but you can't hear it due to the blaring jukebox behind you. No, you're not trapped in an '80s dive bar—you're at Cans Bar and Canteen, a unique concept focusing on "old school fun" that opened at 500 West Fifth Street in Charlotte in 2006 before closing in 2009.

The one-hundred-year-old building often referred to as "The Cotton Mill" had three floors, all of which were quite often crowded with young people eager to buy whichever tallboy was on sale for a buck that day. In addition to the jukebox, there was often a DJ on hand providing the music. Downstairs, you could play beer pong or pool, and the third floor was a small rooftop terrace. Two long bars faced each other on the main floor, and from them, bartenders would sling beer from the taps, in bottles and, of course, in cans.

True to its name, canned beers were the most popular choice at Cans, which stocked more than thirty aluminum-clad offerings. Those thirty were dominated by larger brands like Budweiser, Miller, Coors, Icehouse, Labatt, Heineken, Old Milwaukee, Pabst Blue Ribbon and Schlitz, but mixed in that long list of lagers, you could also find craft offerings like Dale's Pale Ale and Old Chub from Oskar Blues, as well as Young's Double Chocolate Stout from England.

A History of Brewing in the Queen City

Most reviews and remembrances of Cans never mention the few craft beers it sold. Instead, they are peppered with words like "loud," "frat boys" and "meat market." And given the copious amounts of tallboys sold in the place, I'm sure you're asking: why is it even being mentioned in this book if it clearly was never a craft beer destination? It's a very fair question.

When Cans came to Charlotte, there were two other locations: one in Chicago and one in Milwaukee. The Milwaukee location has since closed in 2012, leaving only the original Chicago location. The Charlotte location holds a unique distinction among those three: it was the first and only of the locations to feature an in-house brewery and canning line.

Well, to call it a brewery would be a bit of a misnomer. The beer wasn't actually brewed at Cans. Instead, a vendor supplied it with "wort," or unfermented beer, which it would pour into its four 155-gallon, stainless-steel tanks before pitching the yeast in to start the fermentation process. Once finished, they were canned, and patrons could drink them there or take six-packs home for $8.99 each.

Four beers were fermented and then canned in-house : THP Light, THP Dark, THP Amber and THP White. The THP stood for "Three Headed Productions," which owns Cans Bar and Canteen and four other Chicago-based restaurants. Those three heads belong to owners Tommy Wang, Matt Lindner and Jay Runnfeldt, and a cartoon version of each appeared on the THP cans: Tommy's on the Light, Matt's on the Dark and Jay's on

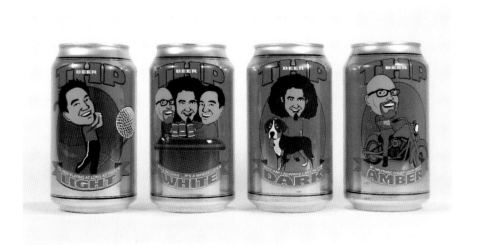

The four beers that Cans Bar and Canteen canned on-site featured the faces of owners Tommy Wang, Matt Lindner and Jay Runnfeldt. The Charlotte Cans location was the only one to can its own beers. *Photo by Russ Phillips and www.craftcans.com.*

the Amber. All three were featured on the Belgian White, which was Cans' signature beer.

This "brewery" and canning line took up only four hundred square feet—a fraction of the thirteen thousand square feet that Cans had spread out over three floors. I've spoken with many people who used to frequent Cans, and not a single one of them knew it "brewed" and canned its own beers. For that reason alone, I thought it was worth including.

Cans closed in January 2010, but if you feel like you missed out on the Cans experience, you're in luck. Today, an upscale nightclub called 5th Element Restaurant and Lounge occupies the Cotton Mill building—but if you step into this building on a Sunday when the Carolina Panthers are playing at home, you are likely to find "Cans Recycled." During Panthers home games, 5th Element allows all of Cans' old bartenders, servers, DJs and, of course, patrons to celebrate as they did for so many years in Charlotte. You won't find any of the THP beers, but you can bet there will be plenty of tallboys on hand.

THE OLDE MECKLENBURG BREWERY

John Marrino's passion for Germany's beer began in 1993, when he moved to that country to work for a water treatment company. He worked there for several years and also in England for a bit before moving back to the States in 1997 to run a New Jersey company that his employer had purchased. Years later, his employer purchased another company in Vermont, and after outgrowing that facility, it built a new one in Charlotte. That is what brought him to the Queen City.

In 2002, a large conglomerate bought the company John was working for. He stayed on for a little while but soon realized he couldn't keep doing it anymore. He didn't know what he wanted to do, but he knew he wanted to do something he was passionate about.

In the meantime, John was going to enjoy the time off with his family. He, his wife and their then eighteen-month-old daughter boarded an RV and headed west, going all the way to Arizona before the mountains carried them north all the way to Canada. After heading back down into the States, John and his family stopped in Missoula, Montana. As he sat by the fire, he read a newspaper article about someone who was bringing back the Narragansett Brewing Company in Rhode Island. "I turned to

my wife and said, 'Charlotte doesn't have a brewery,'" John said. "I could come back to Charlotte and not only have a job but get the German beer that I missed so much."

Without a brewery in town to consult for advice, John began educating himself not just on the business of beer but also on brewing it. He turned his garage into a brewery, complete with temperature-controlled freezers so that he could lager the beers he hoped to one day brew on a large scale. "Right out of the gates, I said I'd make a Dusseldorf Altbier because that's my favorite," John said. "In the sixteen years I was in Germany or visiting Germany, I never knew anyone who had an authentic German Altbier and didn't like it."

John would look for Altbiers and other German styles at the grocery store but come away empty-handed. Sure, he could find imported German brands, but he often found them to be out of date and skunked by the time they made the long voyage over from Deutschland. For John, these couldn't compare to the beers he drank fresh from the source in Germany. On one hand, John would be taking a risk by producing traditional German-style beers, but on another, he would be distinguishing his brewery that much more against other breweries. He wanted to brew beers that had mass appeal, noting that many breweries grew due to their "session beers," like New Belgium's Fat Tire or Sam Adams' Boston Lager. "By nature, I'm a contrarian," John said. "By doing traditional, German-style beers, I was actually being different and charting a different path than most microbreweries."

John learned much from a visit to the Great American Beer Festival and his visits to regional breweries, but he knew that his experience brewing in his garage brewery was no substitute for what he could learn from a seasoned German *braumeister*. He found that brewmaster in Markus Bormann, whom he brought over from Germany to serve as a consultant and bestow upon the burgeoning brewery the practical aspects that it wouldn't otherwise know in its infancy.

One of Markus's first tasks was to teach Carey Savoy, with whom John had worked in the water treatment business, how to brew. While Carey enjoyed craft beer, he had never so much as tried his hand at homebrewing. In fact, he had been working as a welder to that point. So what made John think Carey was qualified to be the Olde Mecklenburg's first head brewer? "I didn't want to retrain or untrain someone's habits; I wanted to train someone the way we wanted it done here at OMB," said John of Carey. "None of our brewers have come from other breweries. All are trained in-house, and none have any formal training."

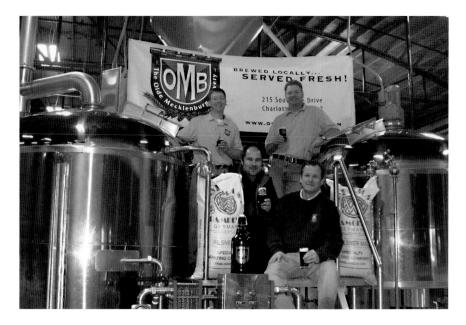

Back left to right: Brewer Carey Savoy, Jon Hayward, owner John Marrino and consultant Markus Bormann pose for a shot in the Olde Mecklenburg Brewery's brewhouse.

It was a unique approach to hiring a brewer, but John was familiar with Carey's skill set. As a welder, Carey had a meticulous attention to detail, despite doing the same thing day in and day out. Brewing is a procedure, John said, just as much science as it is art. He knew that Markus could teach Carey to implement and maintain the techniques necessary to produce German-style beer of the highest standard.

As veterans in the water treatment business, both John and Carey were familiar with things like pumps, tanks, pipes, valves, pressure, temperature and flow. Despite their relative newness to the brewing industry, this specialized knowledge served them well when it came time to build the taproom and brewery. They did much of the work themselves, and to this day, Carey will still don his welder's mask and gloves if a pipe needs to be run.

He will likely have to do that very soon, as the Olde Mecklenburg Brewery plans to add two more 120-barrel fermenters and one more 60-barrel conical fermenter, thus quadrupling the brewery's capacity. This will allow it to brew some additional styles in 2013 while still meeting Charlotte's huge demand for its Copper, which it is currently brewing at the rate of 130 barrels per week.

Of course, Copper is an Altbier, the flagship beer that John set out to brew long before actually building the brewery. He also intended to brew a pilsner,

but that didn't happen until 2011, when the brewery released Captain James Jack Pilsner. This beer now joins Copper as a year-round offering. Before brewing this pilsner, the brewery offered a hybrid of a kölsch and a pilsner called, naturally, Kölsner. This beer was offered as a seasonal for a couple of years, as was the Mecklenburger, a Helles lager. Its current seasonals include Früh-Bock, Mecktoberfest, Dunkel, Bauern Bock and Yule Bock. The Mecktoberfest won silver in the "German-Style Märzen" category at the 2012 Great American Beer Festival. In 2012, it also brewed Rein Pale Ale, a winning recipe from the U.S. Open homebrewing competition that was held at the brewery. With the additional tanks coming, the Olde Mecklenburg Brewery plans to try its hand at other styles, even if in small batches at first. It released Fat Boy Baltic Porter, the first of these small-batch offerings, on January 12, 2013.

John and the Olde Mecklenburg Brewery put freshness above anything else, and for that reason, he does not plan to expand distribution outside of Charlotte any time in the near future. And while his beers seem to be omnipresent in the city, in reality the Olde Mecklenburg Brewery only makes up around 1 percent of beer sold in the Charlotte market.

When John opened the Olde Mecklenburg Brewery in 2009, there were no locally owned breweries in the city. With no proof that Charlotteans would support it, he took a chance by following his own passion and bringing German-style beers to the Queen City. In doing so, he showed that modern-day Mecklenburgers do have a thirst for local beer, no matter the style, and he paved the way for other breweries to come into the city as a result.

While it is obviously still a business, John welcomes these breweries into Charlotte and acknowledges that there is room for all of them. "Local used to be North Carolina beers, now local is Charlotte beers," John said. "Bars are dedicating more taps to local beers than ever now. There's room for us to grow, and there's room for these other breweries to grow right alongside us."

Four Friends Brewing

Of Charlotte's current breweries, Four Friends has been established the longest. The four friends—Jon and Beth Fulcher and Mark and Allyson Kaminsky—incorporated the business in 2007 but didn't sell their first beer until August 1, 2010. Until that first pint was poured, the friends devoted their time to brewing (sometimes two to three times a week while

Jon Fulcher, one of the friends that makes up Four Friends Brewing, has worn many hats at the brewery since its opening in 2010. *Photo by Eric Gaddy.*

perfecting recipes), sourcing equipment, finding a location and finalizing the beers that would make up their initial lineup. Jon Fulcher, who had been a homebrewer for many years before deciding to go pro, saw how the city of Asheville, North Carolina, embraced craft beer and thought Charlotteans would do the same. "We realized it wasn't a local phenomenon but a national trend," he said. "Why would Charlotte be left out?"

Mark and Allyson live in Virginia. They planned on moving to Charlotte, but the housing market collapsed. Jon and Beth Fulcher moved to Charlotte from Wilmington in 2005. At that time, they noticed that the city was brimming with fellow transplants from other parts of the country. These people may not have identified with Charlotte, but they did often identify with locally brewed beers. People in Pennsylvania would loyally buy Yuengling, while former Texans might opt for Shiner Bock. As with other cities across the nation, Jon and the rest of the friends wanted Charlotteans to have a hometown brewery of which they could be proud.

The friends found a location in a 2,500-square-foot warehouse in the Steele Creek area, and in it they set about brewing the British styles they all enjoyed so much. They opened up with Queen City Red, Queen City Blonde, Uptown Brown and Bohemian Beauty. Since opening, Jon has changed that lineup to meet consumer demand, even if he initially planned on brewing only British-style beers. The brewery's best-selling beer is its i77

IPA, a beer as American as the long stretch of asphalt for which it is named. "We can't force the consumer into what we want," Jon said. "We came out of the gates wanting to brew only high-gravity, specialty British beers, and that's just not enough of a market to sustain a business. We have to go where the market tells us to go."

Right now, that market is telling Four Friends Brewing to expand. It currently brews around seven hundred barrels a year, which is about 50 percent of its capacity—even when counting the two large fermenting tanks the brewery just added. With the brewery seeing an 18 percent increase in sales from month to month, it would only be a matter of time until it would be unable to meet demand.

It has purchased an adjacent portion of the warehouse it shares with other businesses, thereby giving it five thousand square feet of space (twice its current size). To make the most of this space, it will knock down the wall separating the two sections to create a much larger brewing area.

A new taproom will run along the perimeter of the brewery in an L-shape. The current taproom is not separated from the brewery, and because there is no heating or air-conditioning, Jon rarely opens it to the public. He hopes the new taproom will bring more people to the brewery to see the process and better appreciate the work that goes into locally brewed beer.

Next year, Jon foresees production increasing to two thousand barrels a year. In the next two years, he hopes the brewery can again increase fermenting capacity, add a bottling or canning line and hire five to ten more employees. He wants to see Four Friends Brewing grow, just as he does other small businesses in the area. "Every time we can, we try to get people to understand why it's important to support local," Jon said. "It brings jobs here, it creates tax revenue here. Charlotte brings in a lot of big businesses, but small businesses are very important."

Ass Clown Brewing

The name for Matt Glidden's mortgage company—Interesting Mortgages—is about as tame as it gets, yet when it came time to choose a name for his brewery, he pulled no punches. Sharing an office with this mortgage company in Cornelius, North Carolina, is Ass Clown Brewing, a name as unforgettable as the beers brewed therein. "You get mixed reviews," Matt said of his brewery's name. "But like I tell everyone, there's not one beer

Despite his brewery's name, Ass Clown Brewing's Matt Glidden takes his beer seriously—though he will occasionally honk the bicycle horn after pouring a pint. *Photo by Eric Gaddy.*

or style of music that everyone loves. I did it because my memory kind of blows, so I wanted something where you could go to a beer festival and there would be no way you could forget the name."

That provocative name has proven popular at Charlotte's beer festivals, where craft beer lovers line up in droves for beers that sound more like something you would find on a plate than in a pint. The brewery was voted "N.C. Brewer of the Year" by attendees of the North Carolina Brewers and Music Festival, held in Huntersville on May 12, 2012.

Of the one hundred or more Ass Clown Brewing beers, some of the more popular flavors (as Matt refers to them) are Vanilla Bean Chocolate Brown, Orange Spiced IPA, Dark Chocolate Blueberry Porter and Buttered Apple Pie Amber. For the last one, Matt actually throws sticks of butter into the boil. He has to chill it down to emulsify the butter so that he can strain it out prior to fermenting the beer. He also recently brewed a Raspberry Jalapeno beer and a Bacon Oyster Stout. "I'm a big food person," said Matt, who gets much of his inspiration from food. He's brewed with bacon, hemp seed, mint, anise, chocolate, peanut butter and seemingly every fruit under the sun. "I taste something and I'm like, 'Why can't this be in liquid form?'"

A History of Brewing in the Queen City

Matt didn't always brew with such innovative ingredients. When he started homebrewing in his garage eight years ago, he brewed traditional styles and followed the instructions on the recipe kits. After a few hundred batches, though, he grew bored. "I just like beers that are different," Matt said. "Anybody can brew beer; why do I want to make a plain beer when you can get that anywhere?"

Ass Clown Brewing's beers certainly aren't the type you can get just anywhere. The brewery had a few accounts in the area but had to pull out because it was having trouble keeping up with demand since it is still brewing only forty-five gallons at a time on a small system. As such, the best place to find Ass Clown's beers is at the new taproom, located in Suites E and F at 10620 Bailey Road in Cornelius, North Carolina.

Matt keeps nine different beers on tap at any given time in the taproom, but he has close to one hundred kegs in the brewery's cold room waiting to take the place of any kicked kegs. He has a 265-gallon system in the warehouse, which can be seen through a large glass window in the taproom, but right now he's still brewing 45 gallons at a time. Soon Matt will start brewing on the larger system, which he hopes will allow him to supply more bars with kegs. He also hopes to start selling beer in twenty-two-ounce bombers as well.

Many appreciate the sheer variety of Ass Clown Brewing's beers, while others lament that the brewery lacks year-round beers that are always available. "We get a little bit of slap here and there because we really don't have many staple beers," Matt said. "But I feel like out of the one hundred beers we brew, more than a quarter could be staples if we wanted them to." He plans to add more year-round beers in the future, such as the Vanilla Bean Chocolate Brown or his new Chocolate Sea Salt Stout.

Matt, who grew up on a dairy farm in Addison, Vermont, wants Ass Clown Brewing to be known as a "green" brewery. Once he starts brewing on the big system, he plans on brewing in triple batches to conserve water and cleaning supplies. Matt uses his spent grain to create dog treats; he also uses spent grains and hops to make soap, which can be purchased at the taproom. He plans on installing solar panels soon.

Matt's eco-friendly ways also extend to the taproom itself. Wooden pallets stacked on their sides divide the taproom into two areas, with white lights shining through the gaps in the pallets. The lighting adds much to the taproom's eclectic yet comfortable ambiance: lamps made from growlers hang just above a thick bar, which was fashioned from the roof of an old schoolhouse. Mason jars do the same, illuminating a section of the taproom

that features walls of burlap sacks that once held coffee. And what would a taproom be without a chandelier made of bicycle horns? Those same horns are affixed to some of the tap handles, which Matt and the other bartenders will often honk after pouring a beer.

This is Matt's mortgage office; this is Matt's brewery. Though Matt occupies two suites in the retail park, don't think for a second that Interesting Mortgages is in one and Ass Clown Brewing is in the other. There is no distinction between the two, and clients of Interesting Mortgages often end up having a beer. "Usually they sit at the table or bar," says Matt of Interesting Mortgage's clients. He jokes, "I make sure they drink first."

These two businesses will operate out of the same space until Ass Clown Brewing is profitable enough to allow Matt to get out of the mortgage business. Until then, however, you can find Ass Clown Brewing and Interesting Mortgages sharing a very creative space in Cornelius, North Carolina.

NoDa Brewing Company

When John Marrino visited Dusseldorf, he returned to the States intent on bringing that city's Altbier to Charlotte, which he later did with the Olde Mecklenburg Brewery's flagship Copper. When Todd Ford visited that city and others the world over, however, it made him pine for the West Coast–inspired beers he had come to love in the States. "I would really appreciate all of the styles they had," said Todd, who flew to many cities as a pilot before becoming co-owner of NoDa Brewing with his wife, Suzie Ford. "But the longer I spent in Europe, the more I missed West Coast beers."

When he wasn't flying all over the globe, he and Suzie spent as much time as they could immersing themselves in Charlotte's beer culture. Through the Charlotte Beer Club and Carolina BrewMasters, they met many like-minded people, but there was one person in particular that everyone insisted they meet. Chad Henderson's brewing philosophy was very similar to Todd's—so much so that members of the Carolina BrewMasters told the two they would get along well. When they did finally run into each other, they understood why. "We kept hearing this guy's name, and we'd never met him, but we did finally meet him at the Pizza Peel," Todd said. "When we actually met, it was like, 'Man, they were all right.'"

They hit it off instantly and got to know each other better by brewing together and drinking one another's beers. The two both had

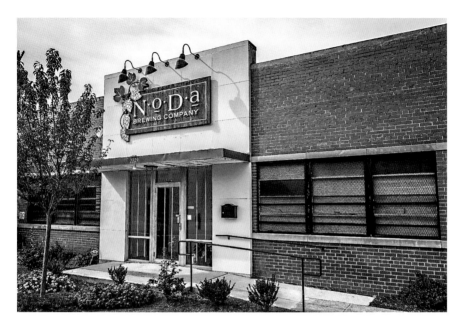

NoDa Brewing Company renovated an old warehouse space at North Davidson Street and East Twenty-sixth Street. It opened its doors on October 29, 2011. *Photo by Eric Gaddy.*

an appreciation for West Coast brewing practices, which Chad defines as "a unique approach to pushing the envelope of at least one aspect of the beer." Whereas Todd had been influenced by Sierra Nevada as a homebrewer in the '90s, Chad drew inspiration from breweries like Founders Brewing, Weyerbacher and Dogfish Head. He first met Dogfish Head's founder, Sam Calagione, at the Denver Rare Beer Tasting, an event that Charlotte-based Pints for Prostates puts on during the Great American Beer Festival each year. Later, he made it a point to volunteer for as many local beer events as he could, and when he heard Sam was going to attend the World Beer Festival in Raleigh, he jumped at the chance to help pour beer at that brewery's booths.

To Chad's surprise, Sam remembered him from the tasting in Denver. At the end of the day, after two long sessions in which Chad educated festival goers about the Dogfish beers he poured, Sam told Chad that he knew more about his beer than many of his employees. He wanted to send Chad a token of his thanks, and a few days later a box containing a hat, a bottle opener and a 2006 bottle of Dogfish Head's Olde School Barleywine arrived at Chad's door. Chad marked the bottle "From Sam" so as not to accidentally drink it and told his roommate that he would not

open that bottle until it was either ten years old or he had achieved his dream of becoming a professional brewer.

He didn't have to wait ten years.

On October 29, 2011, Todd and Suzie opened NoDa Brewing's doors, with Chad as their brewer. That night, surrounded by friends and family, Chad opened the vintage bottle given to him by Sam Calagione. "That was the best beer I've ever had, because of the meaning behind it," Chad said. "You dream of doing something like that for so long. The concept of us seeing this building, breaking walls down, building new ones in their place, struggling with regulations—and to be able to embrace it all in a glass, in a packed room filled with people who had seen us grow. All of that was tasted in every sip."

Just about every Tuesday since then, the brewery has unveiled a new, small batch beer as part of the NoDable Series. In his travels, Todd had seen Ben Edmunds take this approach in his Portland brewpub, where he would tap an experimental batch every Wednesday. Some were enjoyable, others less so, but they were all fun to try and always educational. It was another idea that Todd and Chad saw eye-to-eye on. "Even before NoDa, I really loved the idea of doing multiple batches to really see what people wanted," Chad said. "It's a great challenge. It keeps the mind constantly trying to find something new. That's the essence of craft brewing—how do you express yourself in a different way over and over again?"

Through the NoDable Series, Chad has expressed himself with everything from a maple-infused double IPA to a version of Coco Loco that's been run through cherries and green M&Ms for Valentine's Day. Some of these beers have found their way into the taproom for more extended stays. Such was the case with Ghost Hop, a white IPA; NoDajito, a mojito-inspired witbier; and Midnight Madness, the black IPA that kicked off the NoDable series. If you want to try a NoDable beer, you have to visit on a Tuesday night, as they rarely last past then. There are no growlers, and none are bottled. To this point, NoDa Brewing has only bottled two beers: TriUmphant Tripel and Pacific Reign, a double IPA brewed with honey. The brewery is looking into alternative packaging options for next year.

In March 2012, not even five months after opening, NoDa Brewing purchased three thirty-barrel fermenters from the Olde Mecklenburg Brewery, which was also expanding and replacing those tanks with bigger ones. By the time you read this, it will have likely added another sixty-barrel fermenter. It also plans to make better use of its space in the future and enlarge its cold storage space.

Chad Henderson, NoDa Brewing's head brewer, celebrates as he, Matt Virgil (left) and Todd Ford (right) brew on the big system for the first time in October 2011. The brewery's first batch was Ramble on Red. *Photo by Tom Henderson Photography.*

That '06 Olde School might have been the best beer Chad has ever had, but the best hours of his life, he said, were spent at the 2012 Great American Beer Festival's award ceremony. It was there that, not yet a year old, the brewery received a silver medal for its Coco Loco in the Robust Porter category. They weren't prepared to win anything, and yet no sooner did the presenters read "Coco Lo—" than the whole table erupted in cheers. Chad, Todd and Suzie made their way to the stage, hugging and high-fiving friends along the way. They actually got lost among the crowd while trying to get to the stage.

After the awards ceremony was over, Chad ran to the Dogfish Head booth to find Sam Calagione pouring beer, his voice long gone. "I held up my medal and said thank you," Chad said. "I don't think I would have been brewing if it weren't for him."

BIRDSONG BREWING COMPANY

"Funnily enough, this isn't a story of inspiration, freedom or taking flight like an avian symbol might make you think," said Chandra Torrence,

At twenty-four years old, Birdsong Brewing's Conor Robinson is one of Charlotte's youngest head brewers. *Photo by Tara Switter Goulet.*

one of the owners at Birdsong Brewing. "The real story is a bit more down to earth."

She is speaking of how the brewery got its name while several of the brewery's owners and its brewer were on a brewery research trip in Asheville. While staying at a hostel, they kept hearing a tweeting sound and were convinced that a bird was trapped in their room. They tiptoed around the apartment searching for almost twenty minutes before realizing the sound was coming from their brewer, Conor Robinson. "It was really just the brewer snoring," Chandra said. "He seriously sounds like a bird when he sleeps."

That snoring was due to a long day of drinking made longer by the fact that Conor had been up since very early that morning baking at Great

A History of Brewing in the Queen City

Harvest Bread Company in Charlotte. If you think a baker is an unlikely candidate for a brewer, just turn back to the section on the Mill Bakery, Eatery and Brewery in Charlotte. There's a reason many refer to beer as liquid bread. "It's very close to the baking process as far as the fermentation and how precise you have to be," Conor said. "I had an interest from there."

Conor came to work at the Great Harvest Bread Company through the baking and pastry arts program at Johnson and Wales. It was at this bakery that he met Tara Goulet, who herself was a Johnson and Wales graduate. At Great Harvest he also met his good friend Matt, who taught him how to homebrew. Initially, the two of them would brew their liquid bread once or twice a month and split the batch, but that soon proved too infrequently for Conor. He started brewing weekly by himself while reading as much as he could about beer and homebrewing.

Though he was now frequently brewing alone, that didn't mean Conor was hoarding all of the beer for himself. He brought homebrew in frequently for his co-workers, as well as Tara, who had left the bakery but with whom he still kept in touch. "We'd had a lot of homebrewed beers before, and Conor's were a lot better than anything we'd had," Tara said. "That's when my husband, Chris, and I got the idea of opening a brewery."

Or at least that's how they justified that whirlwind Asheville brewery tour, on which Conor's birdlike snoring gave rise to their brewery's eventual name. In reality, they put in a lot more work than that story lets on. Chris spent close to a year researching how much a brewery would cost and what the business would entail. He and Tara had some beer-loving friends working in corporate America who wanted to invest in a company and be a part of something. Tara and Chris presented a business plan to their friends, and most of them signed on to invest.

Conor recognizes that, given his experience at the time, Tara, Chris and all of the other investors took a big risk in making him Birdsong Brewing's head brewer. "Oh yeah, hire a twenty-three-year-old brewer who has never brewed on anything larger than a ten-gallon system," Conor said. "I guess most investors would tell you you're crazy for doing that."

In deciding on an initial lineup, everyone at the brewery agreed that they wanted to debut with a portfolio of sessionable beers that weren't over the top in any way. "We feel there are a lot of people who might be intimidated by the bigger beers out there," Tara said. They hoped to open with a California Common, but that did not and still has not worked its way into the production cycle (though it may, Conor says). Instead, the brewery opened with Free Will Pale Ale and Minimum

Wage IPA. A couple months later, it put out Higher Ground IPA and Lazy Bird Brown, which are the brewery's number one and number two bestsellers.

Just behind those in sales but perhaps exceeding them in celebrity is the Jalapeño Pale Ale, which Conor calls "the beer that made us famous." Conor was working hard to have a unique, pilot batch beer on tap at the brewery for every "Thirsty Thursday." He already had Free Will Pale Ale on, and instead of brewing a new beer, he hooked that tap up to a Randall (a device used to infuse beer) and stuffed it with jalapeño peppers. The beer was an instant success. People started coming into the taproom just for that beer, and so many bar managers requested it that the brewery was forced to make it into a production batch. In keeping with the brewery's focus on drinkability, Conor wanted to really emphasize the flavor of the peppers without overwhelming drinkers with heat. Today, he tosses around eight pounds of jalapeños into each twenty-barrel batch.

Those core beers aren't likely to change any time soon, but the brewery wants Conor to follow his passion and explore Belgian styles with its seasonal beers. "That's where my heart and soul is in brewing," Conor said. "The Belgian breweries inspire me the most—especially the history of Belgium's oldest breweries. I think we're becoming more Belgian-centric."

Conor feels that both Birdsong Brewing and NoDa Brewing have the potential to brew Belgian styles that Charlotte will really embrace. For his part, he's introduced Doin' Thyme Witbier, Up on the Sun Saison and the Pride Abbey Ale as seasonals, in addition to several Belgian styles as pilot batches. The brewery has also started aging beers in wine barrels, not unlike some Belgian breweries.

The brewery's name came from snoring that sounded like birdsong, but most of its beer names have been lifted from actual song lyrics: "Free Will," from Rush; "Higher Ground," from Stevie Wonder; "Doin' Time," from Sublime; "Up on the Sun," from the Meat Puppets; "The Pride," from the Isley Brothers; and "Raise a Ruckus," from the Old Crow Medicine Show.

Music blasting while brewing, Conor will continue to produce Birdsong's core styles and experiment with the seasonals in the future, especially his beloved Belgian styles. In just its first year, the brewery doubled its fermentation capacity by adding two fermenters and another brite tank, which is used to condition and carbonate the beer. It also added a larger walk-in cooler, and it is constantly buying kegs as it continues to gain more taps throughout Charlotte.

Though it has accomplished much, Conor wants to ensure the brewery continues to brew its beers to the highest standard, and he notes that he learns something new every day. He reads constantly and is always trying to find ways to improve his beer.

And yes, this baker turned brewer still finds time to make bread when he's not brewing. "When I was working at the bakery, I couldn't stand it," Conor said. "I enjoy making bread at home a lot more now. What was once my career is now my hobby, but I love beer so much that I don't even see this as work."

TRIPLE C BREWING

Chris Harker and Chris Murphy share much more in common than the same first name. Both are homebrewers, both worked in the mortgage industry and both got laid off after the housing market collapse—Chris Harker twice, Chris Murphy thrice.

The instability of the housing market forced the two to consider other options. Chris Harker considered opening a barbecue restaurant but didn't like what he saw when it came to the expenses and hours. He circled back around with Chris Murphy and his wife, Christina. Though both of them homebrewed, neither Chris considered starting up a brewery until Christina proposed just that over lunch at Cabo Fish Taco one day. "We just decided to take it to the next level," said Chris Murphy. "We were like, 'Do we seriously want to do this?' We had homebrewed together, and we all thought we could start a brewery together."

Chris, Chris and Christina—I don't need to tell you how Triple C Brewing came to find its name.

If there were a fourth "C," it might stand for Colorado, as that's where the brewery found Scott Kimball, its head brewer. Scott was working at the Eddyline Restaurant and Brewery in Buena Vista, Colorado, when the three Cs found his résumé online. When they contacted him, he was at his parents' home in Maryland for the holidays. Chris Murphy was with his own family in nearby Northern Virginia, and Chris Harker made the drive up so they could all meet. "It wasn't so much of an interview as it was us just sitting around talking about what we love about beer and why we love it," Scott said.

Over beers, the three discussed Scott's experiences as a professional brewer, which started at the Fordham and Old Dominion Brewing

Company in Delaware. Thanks to a friend who worked there, Scott got to know the staff and worked for free at first, as at that point he was a homebrewer without professional brewing experience. When that friend left, Scott took his spot. Within a month, he was brewing by himself in the large, fifty-barrel brewhouse.

He eventually got tired of the automated process, which allowed for little experimentation, and that's what inspired him to head out west to the Eddyline in Colorado. This was a smaller brewery, but he had more freedom—and it was even more freedom that lured him to Charlotte. "That was a big draw, because I'd spent my entire brewing career helping to brew other people's beers," said Scott. "It feels different when you design the recipe. You have more ownership over the process. I saw a lot of potential here in Charlotte and thought these guys were going to do things right."

Scott later mailed some more of his beers to Charlotte for the three Cs to taste, including a smoked amber ale that he had brewed for the first time. Many thought they were crazy for including a smoked beer in the initial lineup, but the subtly smoked beer would later become the brewery's flagship. Chris Harker may have put aside his plans to build a barbecue restaurant, but there's no reason his beer can't be smoked.

Triple C Brewing Company incorporated in October 2011 and leased its current location on New Year's Day 2012. It set to work demolishing parts of the warehouse while also making a concerted effort to preserve others, which garnered it a nomination for a historic preservation award. Inside, the group simply cleaned up the concrete floors and left the red brick walls. The taproom's bar and tables were all fashioned out of reclaimed, one-hundred-year-old pine from an old mill in Gastonia. Wood slats wrested from shipping pallets sheet the wall behind the bar and wrap around the large glass window looking into the brewery. All of this works to create one of Charlotte's most modern and minimalistic taprooms.

The brewery has an abundance of space in its warehouse, and Chris Harker noted that it is a goal to grow into that space. That will likely mean adding to its fermentation capacity and looking into a bottling or canning line down the road. The group doesn't necessarily want to become a regional brewery, Chris Harker said, but they would love for their beer to be available throughout North Carolina.

For now, though, they want to make sure they are committed to the neighborhood they call home. "We want to be labeled as SouthEnd's brewery," Chris Harker said.

A bartender at Triple C Brewing pours a pint of the brewery's popular Light Rail Pale Ale. *Photo by Eric Gaddy.*

With three apartment buildings going up right around the block and a prime spot off of the light rail, Triple C Brewing is a key player in SouthEnd's developing beer scene. The three Cs delivered the very first keg to the Liberty before it opened to the public on August 25. The keg was empty, as it is illegal to transport alcohol on the light rail, but it was a symbolic gesture that signified the brewery's commitment to SouthEnd. (Those that accompanied the keg to the Liberty were able to buy the first pints of Light Rail Pale Ale, as the actual keg had been delivered.)

In addition to Smoked Amber and Light Rail Pale Ale, Triple C Brewing's core five beers also include Golden Boy Blonde, Greenway IPA and Baby Maker Double IPA. The brewery will continue to produce these beers while also brewing seasonal offerings, such as the Up All Night Breakfast Porter that it released in bottles last December. Like Chad at NoDa Brewing, Scott stays busy brewing pilot batches, which are tapped every Wednesday at the brewery.

Many of Charlotte's breweries tend to have an overarching philosophy that governs the beer they brew: The Olde Mecklenburg Brewery has its German styles; Four Friends started out with a British slant; NoDa prides itself on putting its own unique twist on the West Coast's beers; and Birdsong

wants to focus more heavily on Belgian styles. The guys at Triple C, though, just want to make good beer. "I pride myself on using the best ingredients," said Scott. "Whether they're German, English or American, I don't really care as long as it tastes good."

Aside from their five core beers, Scott and the three Cs plan to brew a variety of styles in the future, whether as seasonals or pilot batch beers. "I don't think we want to get pigeon-holed," said Chris Harker. "We always want to mix it up. We all love different styles of beer and want to keep creating different beers."

Chris Harker is quick to note all of the help Triple C has received along the way, whether from friends, family or other breweries in the state. NoDa Brewing allowed them to tour the brewery and ask questions. Chris Harker went to school with Mother Earth Brewing's president Trent Mooring, who invited him to check out the facility in Kinston. "People have been so helpful," he said. "It's been fun to come to work every day."

HEIST BREWERY

Heist Brewery opened on August 31, 2012, just a week after former bank employees Chris Harker and Chris Murphy opened Triple C Brewing. As their company's name might imply, the guys behind Heist Brewery—at least in attitude—are more bank robber than banker. Founder Kurt Hogan has been associated with a more infamous character his entire life. "Baby Face Nelson—or Lester Gillis—was my grandmother's cousin," Kurt said. "I was always told at a young age, 'Yeah, you're related to public enemy number one.' I knew I was coming to Charlotte, a big banking town, and I wanted the brewery's name to have an edge to it."

That edginess—and Kurt's fascination with the '20s and '30s—is evident in more than just his establishment's name. Mobster-inspired photos hang from the stacked-and-stained lumber covering the brewery's walls. All of Heist's employees played a part in the building's construction, whether by putting paint to wall, sander to wood or bullet to copper. No, not the coppers that the gangsters gracing Heist's walls would have put bullets to but actual copper; in true Heist fashion, Kurt and company took leftover copper piping from the brewery and riddled it with an assault rifle until there were enough holes to let light through. They then hung these pieces from the ceiling in the library bar, where it remains one of the brewery's most talked-about fixtures.

A History of Brewing in the Queen City

A heist, by definition, is not an ordinary robbery but one in which there is a greater amount of loot at stake. In films like *Ocean's Eleven*, capers are carried out by motley crews composed of a variety of specialists, each bringing his or her own unique skill set to the task at hand. Kurt was a homebrewer, but he knew the first order of business was finding someone with more brewing experience. He started his search by writing up a job description and sending it to several brewing schools.

He heard back from Zach Hart, the award-winning brewmaster for the Mash House Brewery and Chophouse in Fayetteville, North Carolina. The two talked on the phone, and in November 2011, Zach visited Charlotte to meet with Kurt in the old mill building that would soon house a brewery. At that time, the crew was in demolition mode, and the place looked like a war zone. "I didn't see everything he saw," Zach said, speaking of the vision of the brewery Kurt had in his head. "There were ten-foot, drop-down ceilings, purple rooms, stairways that were out of code."

While he struggled to envision the same building Kurt had, he knew right away that Charlotte on the whole held a lot of potential for a brewery. Zach was familiar with Charlotte from visiting a friend there almost every month. It was one of his favorite cities in the state, and he had been looking to leave Fayetteville. He came on board in February 2012 and moved his family out

Heist Brewery's Zach Hart pours one of his beers. The brewery's unique tap handles were designed by local artists. *Photo by Eric Gaddy.*

west. (Side note: Kurt's not the only one related to an outlaw; Zach's wife is distantly related to Bonnie Parker of "Bonnie and Clyde" fame.)

Like Zach, Kurt saw the same potential in Charlotte. Though he had a career in the biotech industry, he wasn't happy with it. He went back to school and, after getting his MBA at Vanderbilt University, started to look into opening a brewery. It didn't take him long to see that Charlotte would be a prime area for one.

He had researched several breweries in the New England area, most of which had no food or a very limited menu. Initially, Kurt planned to open a brewery with an oven so that he could do pizza and bread. The more he thought about it, though, the more he realized he didn't want the brewery to be a place where someone would have a beer or two before heading out to dinner. He had already secured the building and hired Zach when he began to lean toward the idea of having a full kitchen. "I decided we would be a true brewpub," Kurt said. "And if we're going to be a brewpub, then we're going to be on the forefront of what people want to see out of a brewpub. It's become more than beer nuts or pretzels on a string."

Zach was good friends with Rob Masone, who had been the original chef at the Mash House in Fayetteville before opening the Braz-N-Rabbit and then later serving as an executive chef for a catering company. Zach invited him out to Charlotte to see the place and speak with Kurt. He felt a good vibe from the start and signed on as Heist Brewery's executive chef. "We soon went from the idea of someone shoveling a few pizzas to having a full menu," Kurt said.

And what a full menu it is. Heist's menu does not contain typical tavern fare but rather something Chef Rob refers to as "twisted American cuisine." Shrimp aren't fried—they are rubbed with chili, wrapped in lemon-wasabi cotton candy, skewered and then stabbed into a piece of granite. Corn dogs aren't frozen and reheated—they are made with pieces of Kurobuta pork belly that are braised in milk and honey. "We're really just an outside-the-box, sky's-the-limit, we-can-do-anything sort of place," Kurt said. "Whatever gets in our way, we'll figure it out. We wanted to build a brick oven. They said, 'Wait a minute, you want to build a brick oven? No, no, no, you have to buy one.'" Because the brewery plans to produce enough bread to sell to farmer's markets, it wanted to custom build its own brick oven. It eventually got past all the regulations and was able to build a four and a half by eight foot brick oven large enough to hide Hoffa in.

It will soon use that brick oven to produce a variety of breads, many of which will be created using the spent grains from the brewery. By selling

these breads in the farmer's market, it will allow the brewery to get its name out in another area and let people know that it is more than just a brewery. "I really want to treat the breads the same way we treat the beers," said Kurt. "I've always wanted to do gourmet-style, artisan breads. The old-school style, slow-cool, overnight fermentations. It's like if you took a time machine back two hundred years ago."

The brewery could nearly create a baker's dozen of bread styles using the leftover spent grains, as it typically keeps nine to twelve styles on tap at all times. So far, the I2PA imperial IPA has proven most popular among patrons, but Heist also brews a light lager, several Hefeweizens, a red ale, a porter, a Belgian dubbel and an oatmeal stout, just to name a few. Brewing so many styles consistently is a challenge, especially in a small brewhouse such as Heist's. The brewery is looking to add another fermenter that would give it 40 percent more capacity and allow it to brew some other seasonals, since it wouldn't have to devote so much time to several batches of the same beer.

Zach received many medals for his beers while at the Mash House, including his signature Jack'd Up Stout, which was aged in Jack Daniel's whiskey barrels. He plans to start a barrel-aging program at Heist soon so that he can replicate his Jack'd Up Stout and also age beers in wine and rum barrels. One beer he is particularly excited about doing is a Flanders red ale aged in a red wine barrel with cherries. To brew some more experimental styles without taking up space in the brewhouse, Heist also plans to add a pilot batch system.

In this brewery brimming with prohibition-era décor, Zach brews sarsaparilla root beer and other house-made sodas (black cherry, cream and orange cream) for the restaurant—just as so many breweries did in an attempt to stay afloat when the nation went dry. Just as his beer is often used in Chef Rob's creations, so, too, do Zach's sodas find their way into the cocktails prepared by bar manager Stefan Huebner, who was named one of the nation's "41 Most Inspired Bartenders" by *GQ Magazine* in 2010. The cocktails and liquor selection, like the full menu, are just another way Heist Brewery hopes to stand out in Charlotte's beer scene. "We're really establishing ourselves as an awesome center in the beer community, and we're bringing something a little different to the table," said Kurt. "We just really want to show Charlotte something they've never seen before."

With such accomplished specialists behind the bar, in the kitchen and in the brewhouse, Kurt, Zach and Rob are poised to pull off the perfect heist.

Breweries to Come

FREE RANGE BREWING

"All of our beers have stories to them," said Jeff Alexander, who with his brother Jason hopes to open Free Range Brewing in 2013. "They're not just names we throw on a beer. Each one is inspired by a story from our life, family or friends. We want our beers to have something behind them and be something people can relate to."

If you attended the Queen City Brewers Festival or Charlotte Oktoberfest in 2012, you may have been able to try some of these beers, even if you didn't know the story behind them at the time. Art Son of Pale was brewed to commemorate the birth of Jason's son, Art (Pale here refers to his fair-skinned wife). When Jason and Jeff's friends were expecting a son of their own, doctors expressed some concerns with the baby's health prior to birth. The child, Hudson, was born blind. After going through an understandably stressful period, Hudson and his parents are now all doing well. "He is amazing and an inspirational little kid," said Jason of Hudson, who shares his name with the brewery's Saison aged on salted figs. "That beer was brewed to commemorate his birth." Rice, Rice Baby, a rice milk stout Free Range Brewing did in collaboration with Birdsong Brewing, was inspired by Jason's children, who are both lactose intolerant.

Not all of the stories involve children, or even people, for that matter. When Jason's big black Lab Abbie passed away, he brewed Abbie Was Stout, a Russian Imperial Stout that Jason thinks epitomizes what a big beer can be.

"It's really chocolatey, really sweet, and it just makes you feel love," he said. "It was brewed to pay homage to everything Abbie gave to us."

Each of the beers may have its own story, but Free Range Brewing's story is just getting started. Right now, Jason and Jeff are finishing up their business plan and looking at locations for their brewpub, preferably in the Plaza Midwood area. If you have stopped by Common Market in Plaza Midwood over the last three years or so, you may have run into Jason there—he played a large part in building that store's beer inventory and draft program. He and Jeff really relate to the Plaza Midwood neighborhood, and that is why it will be their first choice when seeking a location. When it does come time to build out the brewpub, the brothers Alexander envision a space with an industrial feel that's a bit rough and rustic yet "soft enough around the corners" that families will feel comfortable spending time there.

Both the food and beer crafted at this location will be guided by locally sourced, seasonal ingredients used in creative ways that relate back to Charlotte. "We kind of see ourselves as a modern approach to farmhouse brewing," Jason said. "To me, that means local and seasonal."

Often, the term "farmhouse ales" is used in reference to two beer styles: the French Bière de Garde and the Belgian Saison. To craft both of these styles, farmers or brewers—often there was no distinction—would brew with whatever grains, hops, herbs and spices their harvests had yielded that year. Jason's Bière de Gourde was brewed with a roasted French heirloom pumpkin grown at a farm in Sparta, North Carolina, and the Sun for Sam Farmhouse Ale featured local peaches and wild yeast. He hopes to have a base Saison that he can alter throughout the year to showcase whatever ingredients are available locally at the time.

The food will follow this same philosophy. Jason and Jeff are currently researching local farmers to partner with in providing a farm-to-table-style concept. Usually this approach costs restaurants and patrons more, but the guys at Free Range Brewing hope to keep prices down by offering a simplified menu featuring multiple uses of the same meats and produce. "Value is key for what we want to offer with food," Jeff said. "We hope to be able to keep our prices low enough to keep it super value-oriented but at the same time with the quality and creativity to rival places like Soul and Good Food."

Until it can find a location of its own, Free Range Brewing has entered into an agreement with Birdsong Brewing that will allow it to brew on Birdsong's system and then ferment the beer there in Free Range's own ten-barrel fermenter. It was there that they, along with Birdsong's head brewer Conor Robinson, brewed the aforementioned Rice, Rice Baby collaboration. Prior

to this, Jason brewed a collaboration beer with Catawba Valley Brewing Company called Afternoon Delight. "I love the concept of gypsy brewing," Jason said. "While we're working on raising capital and working out the details, we wanted at the same time to be tenant brewing and getting some beers out on the market."

Jason, who has homebrewed for three years and in November 2011 took a short course on brewing at the Siebel Institute of Technology, will continue to serve as the brewer for Free Range Brewing. The founders are still looking to bring in a chef. They have already had several people interested in investing and will look to secure partners and finalize loans after they finish the business plan. Given the right location, Jason said, it could happen pretty quickly. That's a good thing, because if their beers thus far are any indication, the Alexander brothers have more than a few stories to tell.

THE UNKNOWN BREWING COMPANY

Little is known about a new brewery that hopes to soon call Charlotte home, though with a name like the Unknown Brewing Company that is almost to be expected. Less of a mystery is the brewery's founder, Brad Shell, an eight-year veteran in the brewing industry who hopes to open the Unknown Brewing Company in 2013.

Born and raised in Atlanta, Georgia, Brad started his career in beer at his hometown SweetWater Brewing Company, where he worked as a packaging manager. Afterward, he served as a brewing consultant with Terrapin Beer Company in nearby Athens before heading out to the West Coast as a packaging manager for Rogue Ales in Oregon. While at Rogue, he also served as the brewery's production manager for three years, overseeing the main brewery that distributed to every state in the country. He then took a position as general manager of Fish Brewing Company in Olympia, Washington.

After working with breweries on both coasts, what drew Brad to Charlotte? "I looked at markets where I saw beer at the forefront, and that's definitely North Carolina," Brad said. "And Charlotte's beer scene is really taking off."

In keeping with the name of the brewery, its location is unknown at the time of this writing. Brad's first choice is a twenty-five-thousand-square-foot building on Mint Street, but the city would have to redefine how it zones

microbreweries in order for him to pursue it. The Charlotte-Mecklenburg Planning Department has sponsored a process to do just that. If the amendment is made, Brad could have a groundbreaking ceremony in April and open in mid-July. It's a worthwhile process for Brad, who thinks it is important that a brewery be as close to the heart of a city as possible. "If Charlotte is becoming a beer and microbrewing culture, you have to be near that culture," he said. "You want to be where the action is."

Brad is quick to praise the breweries that call Charlotte home. On the West Coast, he was used to competing with eighteen to twenty other brewpubs in town. Given Charlotte's size, he sees no reason the city cannot support another brewery. "We look forward to breaking bread with the Charlotte beer scene," he said. "We want to have a good time."

Plans for the Unknown Brewing Company call for a five-thousand-square-foot tasting room and a forty-barrel brewhouse with a capacity of eight thousand barrels. The brewery plans to offer only kegs in its first year before distributing statewide. Those kegs will be predominantly filled with West Coast styles, though Brad plans to brew a lot of one-off and seasonal styles that will be "all over the place." He also has plans to institute blending and barrel-aging programs.

The name of the brewery is not some cute placeholder until they release the real name to the public, as Brad recently invited designers on www. logoarena.com to craft the company's logo. He left them—and us—with these words of inspiration:

All we know is that we are good people whose mission is to make really great beer. So our call to you…Step into the Unknown. The name of The Unknown Brewing Company refers to our sense of adventure and commitment to doing things creatively. The American craft revolution was an unknown contender in the world market 20 years ago, but is now at the forefront on styles and innovation. We strive to one day be called the "World Famous Unknown Brewery." We want to convey a sense of mystery and ambiguity to our customers, daring them to take a chance on something out of the normal, to try something "Unknown."

Bibliography

BOOKS

Alexander, J.B. *The History of Mecklenburg County From 1740 to 1900*. Charlotte, NC: Charlotte Observer Printing House, 1902.

Brockmann, Legette, and Charles Raven Blythe. *Hornet's Nest: The Story of Charlotte and Mecklenburg County*. Charlotte, NC: Mcnally of Charlotte, 1961.

Charlotte City Directory 1896–97. Charlotte, NC: Observer Printing and Publishing House, 1896.

Charlotte, North Carolina City Directory. Asheville, NC: Piedmont Directory Co, 1884.

Dillard, Jack, ed. *Once Upon a Frothy Brew: The Best of the Brew Pub Poets Society*. Vol. 1. Charlotte, NC: Deuce Chaps Publishing Co., 1993.

Dunaway, Stewart. *North Carolina Tavern Bonds—Volume 2 (1742–1867)*. N.p.: Lulu, 2012.

Greenwood, Janette Thomas. *Bittersweet Legacy: The Black and White "Better Classes" in Charlotte, 1850–1910*. Chapel Hill: University of North Carolina Press, 2001.

Hanchett, Thomas W. *Sorting Out the New South City: Race, Class, and Urban Development in Charlotte, 1875–1975*. Chapel Hill: University of North Carolina Press, 1998.

Industrial Refrigeration, Volumes 28–29. Chicago: Nickerson & Collins Co., 1905.

Maloney's Charlotte 1897–98 City Directory. Atlanta: Maloney Directory Co., 1897.

Morrill, Dan L. *Historic Charlotte: An Illustrated History of Charlotte & Mecklenburg County*. San Antonio, TX: Historical Publishing Network, 2001.

Rush, Benjamin. *An Inquiry Into the Effects of Ardent Spirits Upon the Human Body and Mind: With an Account of the Means of Preventing, and of the Remedies for Curing Them*. Boston: James Loring, 1823.

Tartan, Beth, ed. *North Carolina and Old Salem Cookery*. Chapel Hill: University of North Carolina Press, 1955.

Tompkins, D.A. *History of Mecklenburg County and the City of Charlotte from 1740 to 1903*. 2 vols. Charlotte, NC: Observer Printing House, 1903.

Van Wieren, Dale P. *American Breweries II*. West Point, PA: East Coast Breweriana Association, 1995.

Walsh's Charlotte North Carolina City Directory for 1905–6. Charleston, SC: Walsh Directory Company, 1905.

Williams, Stephanie B. *Wicked Charlotte: The Sordid Side of the Queen City*. Charleston, SC: The History Press, 2006.

ARTICLES

Batten, Taylor. "Call it BYOB (Brew Your Own Beer)." *Charlotte Observer*, June 25, 1997.

Catawba Journal. "Agricultural Notice." April 4, 1826.

Clary, Ellison. "Carolina Brewery Open for Tour." *Charlotte Observer*, February 14, 2003.

Egleston, Larken. "Woods Brings QC a Taste of Celebrity." *Charlotte Observer*, October 24, 2007.

Gubbins, Pat B. "Saying Goodbye to an Institution—Charlotte Restaurant, Which Opened in 1966, Closes Doors After the Food and Beer Finally Run Out." *Charlotte Observer*, November 5, 2005.

Jameson, Tonya. "Pop the Cork for Loosened Alcohol Rules: Changes Show Conservatism Losing Its Hold in Carolinas." *Charlotte Observer*, September 4, 2005.

London, Ashley M. "Brewing Concern Demonstrates a Can-Do Attitude." *Charlotte Business Journal*, August 29, 2005.

———. "Cans Uptown Locations Lives Up to Name with Brewery." *Charlotte Business Journal*, July 24, 2006.

Mecia, Tony. "Brewer Boom Has Gone Flat Johnson Beer Latest Casualty in Area's Microbrewery Market." *Charlotte Observer*, August 8, 2001.

Miners' and Farmers' Journal (Charlotte, NC) 2, no. 73 (May 25, 1831).

Moore, Pamela L. "Investors with Taste for Risk Can Buy Stake in Microbrewery." *Charlotte Observer*, August 18, 1997.

Paddock, Polly. "There's Something Brewing in an Old Dilworth Café." *Charlotte Observer*, November 14, 1988.

Reed, Vita. "Rolling Out the Barrels." *Charlotte Observer*, May 7, 1994.

Schwab, Helen. "Customers and Quality Vary Here—Woods on South Fare Is Excellent—or Not." *Charlotte Observer*, March 21, 2008

———. "Firkenstein Beer Bubbles Up for a Rock Bottom Halloween." *Charlotte Observer*, October 31, 1997.

———. "Hear the Oompahs? It Must Be Oktober at Rheinland Haus." *Charlotte Observer*, October 2, 1998.

———. "Just a Taste." *Charlotte Observer*, July 15, 2005.

———. "The Mill: Ambitious Bakery Is Highlight." *Charlotte Observer*, April 5, 1991.

———. "Southend Brewery's Long on Good Ales, Funky Atmosphere." *Charlotte Observer*, July 28, 1995.

Smith, Doug. "Another Brew Pub Coming, This in North Mecklenburg." *Charlotte Observer*, April 4, 1996.

———. "Fresh Projects Brewing as South End Enters Second Wave of Redevelopment." *Charlotte Observer*, January 15, 1995.

———. "Getting Ahead in Business—Things Are Brewing on South Boulevard." *Charlotte Observer*, July 3, 1995.

———. "Leaving South End—Microbrewery Gets Fresh Identity, Gives Boost to Plaza-Midwood Area." *Charlotte Observer*, November 11, 1997.

———. "Making Lager in the Lab—Ex-Anheuser Master Aiming for Charlotte." *Charlotte Observer*, April 10, 1995.

———. "Southend Goes North, Plans Lake Norman Eatery." *Charlotte Observer*, May 8, 1998.

———. "South End Goes West—S. Tryon Site to House Restaurant, Do-It-Yourself Brewery." *Charlotte Observer*, December 3, 1997.

———. "South End Microbrewery Partnership Thinks Big." *Charlotte Observer*, June 26, 1994.

———. "South End's Atherton Mill Will Soon Feature Lofts." *Charlotte Observer*, June 18, 1995.

Statesville Daily Record. "'Schweitzer-izing' Beer Is Interesting Process." April 28, 1949.

Statesville Record & Landmark. "Atlantic Company Is One of Charlotte's Growing Industries." March 26, 1955.

Stock, Sue. "Strong Brews Are Muscling Their Way In: Enthusiasts and Beer Makers Cheering Greater Variety on N.C. Shelves." *Charlotte Observer,* September 18, 2006.

Thorp, Daniel B. "Taverns and Tavern Culture on the Southern Colonial Frontier: Rowan County, North Carolina, 1753–1776." *Journal of Southern History* 62, no. 4 (November 1996): 661–68.

Thurmond, Richard. "Cheers: This Bud's Through and Miller's Time Is Up. A Consumer's Guide and an Amusing History of Better Beer Here." *Charlotte Magazine,* April 1996.

Tomlinson, Tommy. "Dilworth Brew Heads Uptown to Jonathan's." *Charlotte Observer,* February 19, 1993.

Walton, Hanes, Jr., and James E. Taylor. "Blacks and the Southern Prohibition Movement." *Phylon* 32, no. 3 (1971): 247–59.

Watson, Alan D. "Ordinaries in Colonial Eastern North Carolina." *North Carolina Historical Review* 45, no. 1 (1983): 24–36.

Wooldridge, James. "Something's Brewing in Charlotte." *Hendersonville Times-News,* January 21, 1990.

Wrinn, Jim. "Mooresville Brewery Is Bottling Success." *Charlotte Observer,* July 11, 1999.

Youngs, Laura. "Finding Sunshine in a Beer Bottle—Merchants Celebrate Decision They Say Will Boost Business, Charlotte's Cultural Image." *Charlotte Observer,* August 6, 2005.

WEBSITES

Atlanta History Center. "Atlanta City Brewing Company Minute Book." http://ftp.atlantahistorycenter.com/MSSf/MSS%201f-99f/MSS%20 11f.pdf.

Brewery Collectibles Club of America. "Atlantic Waves Newsletter June 2004." http://www.bccaatlantic.com/Newsletters/June2004.pdf.

Brewery Collectibles Club of America. "Atlantic Waves Newsletter October 2006." http://www.bccaatlantic.com/Newsletters/Oct2006.pdf.

Bush, Bobby. "Beer Carolinas." Realbeer.com. http://www.realbeer.com/library/authors/bush-b/focus350.php.

———. "Charlotte Oktoberfest 2001." Realbeer.com. http://www.realbeer.com/library/authors/bush-b/focus429.php.

———. "Johnson Beer." Realbeer.com. http://www.realbeer.com/library/authors/bush-b/focus246.php.

———. "Lake Norman Southend." Realbeer.com. http://www.realbeer.com/library/authors/bush-b/focus358.php.

Charlotte Trolley. "Atherton Mill." http://www.charlottetrolley.org/atherton-mill.html.

Greater Charlotte Biz. "Carolina Blonde, Charlestons, and Cottonwoods— Brewing Homegrown Flavor." http://www.greatercharlottebiz.com/article.asp?id=400.

Internet Archive. "The Life of George L. Smith, North Carolina's Ex-Convict: Boldest and Bravest Blind Tiger Man, Who Has Run Blind Tigers in Nearly Every Town in North Carolina." http://archive.org/stream/lifeofgeorgelsmi00smit#page/n0/mode/2up.

The Lost Beers. "Carolina Beer & Beverage, Mooresville, NC." http://www.thelostbeers.com/?page_id=259.

Pop the Cap. http://popthecap.org/.

Richardson, Pat. "Dilworth Brewing Company." Charlotte Eats. http://charlotteeats.blogspot.com/2009/09/dilworth-brewing-company.html.

Rusty Cans. "Atlantic Beer." http://www.rustycans.com/COM/month0504.html.

Southend Brewery & Smokehouse. http://web.archive.org/web/20010215012929/http://www.southendbrewery.com/1.html.

Tradii, Mary. "Hops Restaurant Bar and Brewery." http://www.answers.com/topic/hops-restaurant-bar-and-brewery.

Index

About the Author

A Charlotte native, Daniel Hartis did not start drinking craft beer until he was asked to write about Asheville's breweries for the *Blue Banner*, his school paper at the University of North Carolina–Asheville. He returned to Charlotte in 2008 and continued drinking beer, though he didn't start writing about it again until January 2011, when he started www.charlottebeer. com. On that site, Daniel writes about Charlotte's beer events and brewery news. When he is not drinking beer or writing about it, Daniel enjoys spending time with his wife, Airen, and their two children.